D1361552

Black & White Photography for 35mm

A Guide to Photography and Darkroom Techniques

Richard Mizdal

Amherst Media, inc. ■ Buffalo, NY

Copyright ©2000 by Richard Mizdal
All photographs by the author.
All rights reserved.

Published by:
Amherst Media, Inc.
P.O. Box 586
Buffalo, N.Y. 14226
Fax: 716-874-4508

Publisher: Craig Alesse
Senior Editor/Project Manager: Michelle Perkins
Assistant Editor: Matthew A. Kreib

ISBN: 0-936262-99-0
Library of Congress Card Catalog Number: 99-72183

Printed in the United States of America.
10 9 8 7 6 5 4 3 2 1

No part of this publication may be reproduced, stored, or transmitted in any form or by any means, electronic, mechanical, photocopied, recorded or otherwise, without prior written consent from the publisher.

Notice of Disclaimer: The information contained in this book is based on the author's experience and opinions. The author and publisher will not be held liable for the use or misuse of the information in this book.

Table of Contents

Introduction

This book is the product of twenty-nine years of work in both the professional and academic worlds. Drawing on his extensive experience teaching at the secondary and undergraduate levels, Richard Mizdal has distilled the questions and needs of literally thousands of students into practical, real-world instruction.

☐ Note on Subject Assignments

The assignments that you will be asked to complete throughout this book provide a logical progression that covers all the essentials skills needed for taking and making photographs.

Reading each chapter then completing the appropriate assignment will make your learning experience enjoyable and creative. Pay attention to the advice, reminders and hints provided in grey boxes at the sides of the pages along the way.

You are encouraged to take all the photographs you want, but to achieve a comprehensive understanding of the principles of photography, you should complete each of the assignments in the order they are presented.

☐ About the Author

Richard Mizdal is a practicing photographer and painter who served as a combat photographer with the US Army during the Viet Nam War. Professor Mizdal now divides his time between teaching at the undergraduate level and exhibiting his photographs and paintings throughout the East Coast. In addition, he is the author of a number of articles on fine arts instruction.

"...a logical progression that covers all the essentials skills..."

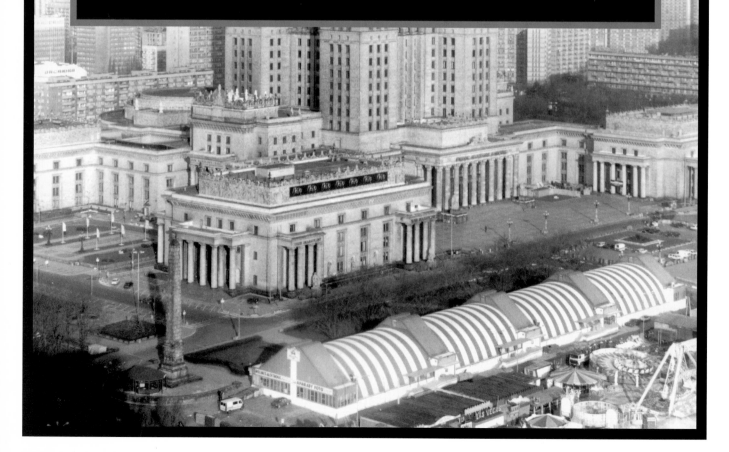

SECTION ONE
Taking Pictures

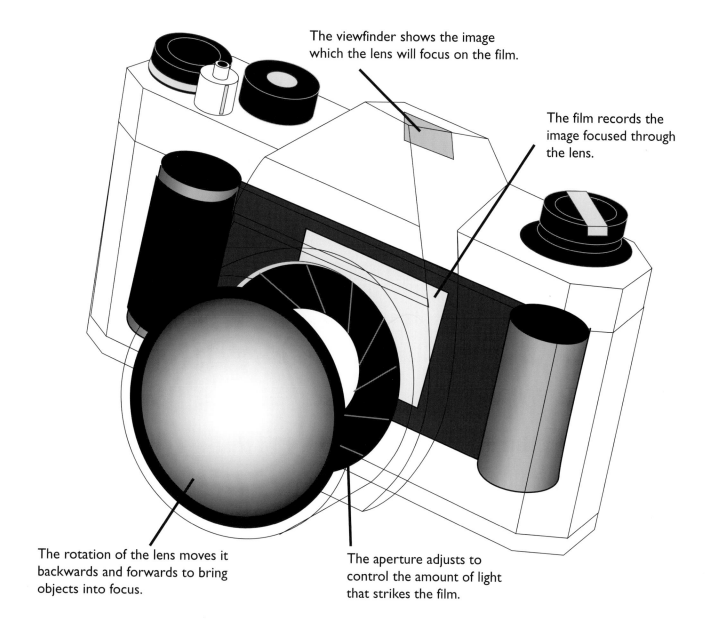

The viewfinder shows the image which the lens will focus on the film.

The film records the image focused through the lens.

The rotation of the lens moves it backwards and forwards to bring objects into focus.

The aperture adjusts to control the amount of light that strikes the film.

This diagram represents the parts of a camera used by the photographer to control the way light hits the film. The first step occurs when the photographer looks through the viewfinder and frames the subject he or she wishes to photograph. In order to achieve a clear image, adjustments must be made to the lens. Different types of lenses bring objects which are varying distances from the photographer into sharper focus; this is accomplished when the photographer turns the focusing ring until the desired sharpness is achieved. The intensity (brightness) of the light that is allowed to hit the film is controlled by the aperture, which adjusts from a larger to smaller opening depending on the f-stop setting. The image that has been focused by the lens and allowed to pass through the aperture then strikes the film for a certain amount of time (determined by the shutter speed) and imprints itself upon the film.

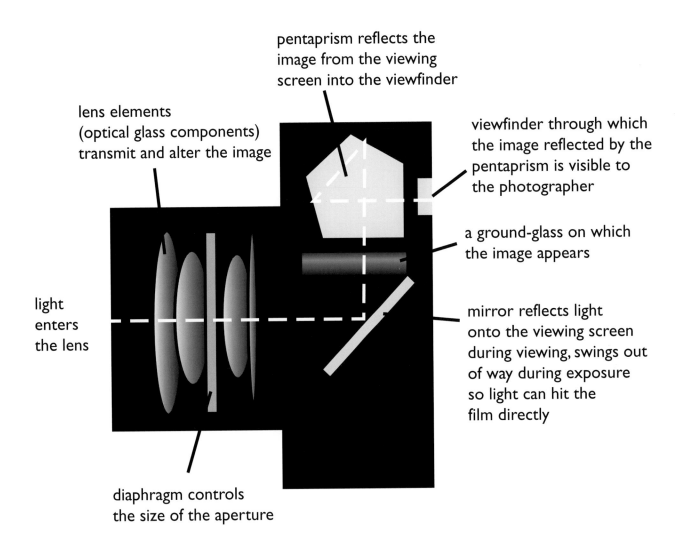

pentaprism reflects the image from the viewing screen into the viewfinder

lens elements (optical glass components) transmit and alter the image

viewfinder through which the image reflected by the pentaprism is visible to the photographer

a ground-glass on which the image appears

light enters the lens

mirror reflects light onto the viewing screen during viewing, swings out of way during exposure so light can hit the film directly

diaphragm controls the size of the aperture

This diagram illustrates the path taken by the light that enters the camera and eventually strikes the film. Light enters the camera through the optical glass components that make up the lens elements. The brightness of the light is controlled by the aperture, and the length of time that the light is allowed to strike the film is dependent upon the shutter speed setting. The light strikes a mirror that reflects it upwards onto a ground-glass viewing screen upon which the image appears. Above this screen, the pentaprism reflects the image into the viewfinder and allows the photographer to see the image. Once satisfied that the image is the one he or she wishes to record on the film, the photographer depresses the shutter release button and starts the exposure sequence. The shutter opens, the light passes through the lens(es), and the mirror swings out of the way to allow the light to strike the film. The film is either manually or automatically advanced, and the camera is ready for the next photograph to be taken.

CHAPTER 1

35mm Camera: Parts and Usage

☐ 35mm Camera: Types and Components

Simply put, a camera is a lightproof box that records light on film. A 35mm camera is a lightproof box that records light on 35mm size film. Some models are fully automated, offering little control to the photographer, while others are fully manual, leaving every decision about the image up to the photographer. Knowing the controls and limitations of your camera (and how to best use them) will make you a better photographer.

• SLR Cameras and Rangefinders. There are two types of 35mm cameras: the Single Lens Reflex (or SLR) and the Rangefinder. Both have advantages and disadvantages – primarily in regard to the amount of control that the photographer can exercise over his images while using them (see page 11). For example, SLR cameras typically feature interchangeable lenses and more advanced systems for measuring light, but are more expensive and heavier than Rangefinders. Rangefinders offer fewer controls, but are lighter and less expensive.

An older style, manual Single Lens Reflex (SLR) Camera.

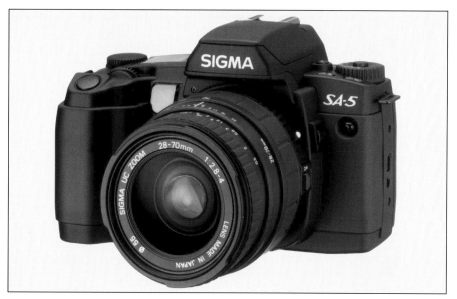

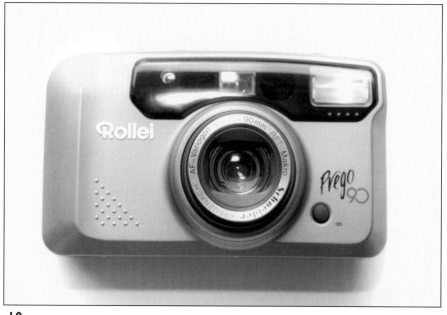

Left, top: A newer model Single Lens Reflex (SLR) Camera.
Left, middle: A basic point and shoot model Rangefinder camera.
Left, bottom: A more sophisticated Rangefinder camera with adjustable settings.

QUICK REFERENCE

SLR: (Single-lens reflex) A camera in which the image formed by the lens is reflected by a mirror onto a ground-glass screen for viewing. The mirror swings out of the way just prior to exposure to let the image reach the film.

Point and Shoot: Camera type that is usually "auto-everything" i.e. they read the speed of the film, advance the film to the first frame, focus, calculate exposure, trigger flash, advance the film and rewind it at the end of the roll.

Rangefinder: (1) A device on a camera that measures the distance from camera to subject and shows when the subject is in focus. (2) A camera equipped with a rangefinder focusing device.

Advantages	Disadvantages
SLR	
Viewfinder displays all that the film records Excellent lens quality Interchangeable lenses Advanced light meter/s More functions (autofocus, shutter speeds, apertures, film speeds, +/- compensation, timers, DX coded film, etc.) Usually more solidly constructed	Heaviest 35mm camera Usually most expensive Noisiest 35mm camera
Rangefinder	
Smaller, lighter More compact Simple light meter Quieter in operation Fewer controls Smallest 35mm camera	Usually non-interchangeable lens Viewfinder sees differently that what the film records Fewer control settings than the SLR (limits occasions for use) Usually poorer lens quality than SLR
Point and Shoot	
Fewest controls Least expensive	Usually very simple if any lightmeter Very few control settings Mass produced, less sturdy than rangefinders or SLRs

The camera that you are using may be automated to any degree, but understanding its controls will aid you in achieving the best possible images of any subject. Understanding and using the controls of your camera are the cornerstones of creative photography and the hallmark of your personal statement.

• **APS Photo System.** APS (Advanced Photo System) cameras offer another option to photographers. While these cameras are also divided into Rangefinders and SLRs, they allow photographers to choose from three different print sizes (including panoramic), as well as to switch film mid-roll.

The principles of picture taking and making are, however, the same for APS systems as for 35mm systems. If you are using a APS system, you will need some different equipment (such as a different size developing tank) to complete the darkroom sections of this book. Consult a salesperson at your local darkroom supply store for specific requirements.

☐ Camera Use

Picture taking should be fun and exciting. Imagine you're driving a wonderful sports car. All the controls can either be thrilling and satisfying or completely intimidating. The same is true of photography – especially with all of the new and complicated cameras available. So that you can enjoy the ride without rushing, here is the procedure for successful picture taking.

Before we get started, though, it's always a good idea to make sure that the batteries are fresh and loaded properly. A diagram detailing proper battery loading is generally provided inside the battery chamber or in the camera's instruction book.

Next, turn the camera ON if it has a switch.

☐ Film Loading

Check to see if there is any film already loaded in the camera. If not, in a shady area, open the back of your camera body. Do not touch any internal part of the camera (either the body or the door). Insert the film, gently pulling out from the canister about five to six inches of its leader and inserting the leader into the take-up spool on the right side of the camera body.

> "...in a shady area, open the back of your camera body."

If you have a manual camera, after gently closing the back of the camera, use the film advance lever to load the film. Make certain that the spool and cogs pull the sprocket holes and begin to wind the film onto the take-up spool. Advance the film with the lever until the film counter says #1.

Auto loading cameras require you simply to lay the film leader at a marked position near the take-up spool. Close the back of the camera with a gentle squeeze. A touch of the shutter button should advance the film to #1.

If the film counter does not register #1, reopen the camera back and reload the film to ensure proper film take up.

☐ Basic Controls

A photograph is created by using a combination of the camera's controls and the lens' controls. They are as follows:

CAMERA BODY CONTROLS
- On/off switch
- ISO/ASA setting of film speed
- Shutter speed setting
- Film advance lever
- Shutter release button
- Other possible settings (program, +/−, compensation, etc.,)
- Film release button
- Film rewind knob

LENS CONTROLS
- Aperture (f-stop) settings
- Focusing ring (manual or auto)
- Filter ring
- Zoom ring on zoom lenses

All of these controls are used in every shot in every variety of natural or artificial light. Each specific combination of these controls will effect the final appearance of the photograph.

☐ **Camera Settings**

Each of these controls features individual settings which must be observed and correctly adjusted before shooting.

1. **On/Off switch.** The camera must be turned on for it to operate.
2. **ISO/ASA setting.** Setting the ISO/ASA tells the camera how sensitive to light the film is. This is crucial for proper exposure.
3. **Focus.** Focusing the lens is necessary to bring the selected area into clarity.
4. **Aperture or F-stop.** The lens' opening (f-stop) must be set. Larger openings (lower numbers, such as f-1.8) admit more light. Smaller openings (higher numbers, such as f-22) admit less light.
5. **Shutter Speed.** Measured in fractions of a second, shutter speed controls how long light will hit the film.
6. **Flash.** Some cameras will display a flash symbol in the viewfinder indicating that the flash should be used to provide additional light.

• **Aperture and Shutter Speed.** After setting the camera's ISO (either manually or automatically) and focusing the lens, the only remaining controls to set are the aperture (or f-stop) and the shutter speed. The aperture controls what areas in the image will be in focus (the depth of field). The shutter speed controls how long the image will be exposed to light. Fast shutter speeds can be used to "freeze" action. Slow shutter speeds can be used to emphasize movement.

The shutter speed and f-stop are always connected and affect each other directly. Once a decision has been made about one of these controls, that setting will determine the appropriate setting of the other. If one is changed, then the other must also be changed.

> "Each specific combination of controls will produce a different looking photograph..."

QUICK REFERENCE

ISO: (International Organization for Standardization) Common film speed rating system used in most English speaking countries. The film speed rating doubles each time the light sensitivity of the film doubles (400 ISO film reacts to light twice as fast as 200 ISO film).

ASA: (American Standards Association) An older film speed rating system that tells how sensitive a specific type of film is to light.

Depth of Field: The area between the nearest and farthest points from the camera that are acceptably sharp in an image.

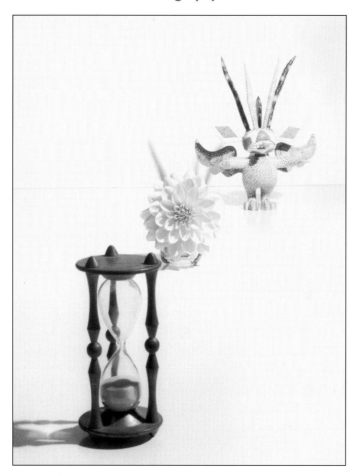
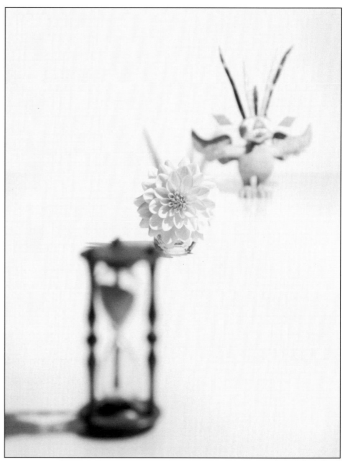

Left: Note how the objects in the fore and background are all in focus. This is an example of a wide depth of field.
Right: This is an example of a narrow depth of field, where only the flower is in focus. The hourglass (closer to the camera) and the statuette (farther from the camera) both fall outside the focal plane and are therefore out of focus.

☐ **Taking Pictures**

• **Holding the Camera.** Hold the camera firmly with your right hand, thumb in back and index finger on the shutter button. Use your left hand to support the camera as well as to focus the lens.

• **Positioning the Camera.** What you see in the viewfinder is about 92% of the scene that the camera is taking. The remaining 8% is masked to compensate for lost area should it be slide film and cropped by the individual slide mount. Look through the camera's viewfinder and try not to allow any sun light to show directly into the lens (this could cause "flare" which appears as a burst of light on the film and negatively affects the final image quality).

While there are no rules, horizontal subjects (like a vast landscape) usually photograph better horizontally, and vertical subjects (such as people) tend to look better vertically. If you choose to shoot a vertical image, simply rotate the camera 90 degrees and take the picture.

QUICK REFERENCE

Focal Plane: The plane or surface on which a focused lens forms a sharp image.

Flare: Unwanted light that reflects and scatters inside a lens or camera. When it reaches the film, it causes a loss of contrast in an image.

QUICK REFERENCE

Light Meter: An instrument which measures the amount of light on a subject. This reading allows the photographer to select the proper exposure.

Focal Length: The distance from the lens to the focal plane when the lens is focused on infinity. The longer the focal length, the greater the magnification of the image.

• **Metering.** SLR cameras contain one or more light meters which measure the light coming into the lens and camera. There are three types of meters:

1. **A spot meter** measures only about 12mm of the center in the viewfinder.
2. **A center-weighted meter** is most common to SLRs. This measures the center of the viewfinder as well as the area outside it but gives preference of 65% to 75% to the center
3. **A segmented meter** measures all of its 4 to 1005 sections across the entire viewfinder area, compares each to its memory chip and indicates a reading.

When the camera is turned on, its light meter is activated. In some SLRs, a slight touch to the shutter button is necessary to activate it. Many photographers prefer to entirely fill the viewfinder's circle of measurement and determine the exposure before recomposing and taking the shot. The meter reads the light and, based on the light, the camera's set ISO and previously set shutter speed and f-stop determines if the exposure is accurate (or under or over exposed). An accurate exposure is desirable to record the scene the way it appears. An underexposed photo appears dark, while an overexposed photo appears light. Each camera has its own system for displaying the light-meter's reading. Systems include match the needle, + or - signs, red or green lights, etc. Read the camera manual to determine the system your camera uses.

• **Focusing the Lens.** Manual focus lenses are focused by turning the front ring on the lens barrel. Autofocus lenses have a sensor placed in the center of the focus screen visible in the camera's viewfinder. To activate it, point the center of the circle in the viewfinder and slightly depress the shutter button. Keeping the shutter button slightly depressed, re-aim or re-compose the scene in the viewfinder and fully press the shutter button to take the photo. If you use auto focus, remember to always press, hold and recompose the shot before taking it. Failure to do so could result in an undesirable focus location.

The act of focusing always results in the creation of three areas:

1. **The foreground** is the area in front of what is focused on.
2. **The midground** is usually where the focus is located.
3. **The background** is located behind the focused area.

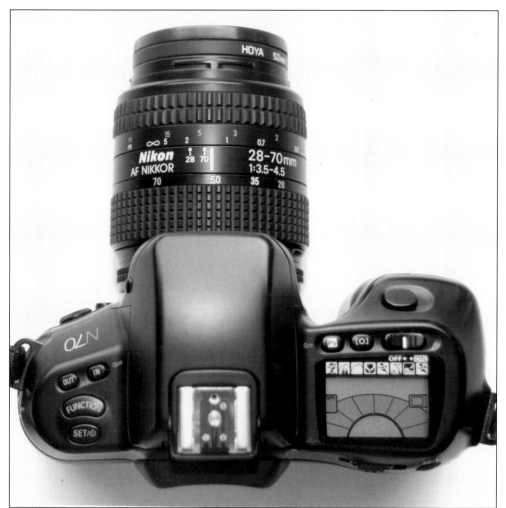

Photo of an SLR, showing top ribbed focus ring and distance scale.

The foreground and background are determined by where the focus point is placed. The focus point that is selected determines the depth of field for the selected aperture or f-stop. If you look down at the focused lens, you will see a center red or white mark which has the same f-stop numbers on the right side as the left side. For example, if you have selected f-16, find the 16's on either side of the center mark and then look at the other ring of distance numbers below the f-stops. The center mark will always point to the exact distance of the object that you have focused on. Here's how to find out what will be in focus when you take the picture. The left side "16" points to the closest distance that will be in focus and the right side "16" will point to the farthest distance in focus. This means that everything within these two points will be in focus, and nearer than the closest point or farther than the most distant point will lose focus progressively.

• **Selecting and Setting the Shutter Speed.** If you are photographing a moving object, select a shutter speed of 1/125 or higher, depress the shutter button to get a light meter reading and then set the f-stop to get a correct exposure.

QUICK REFERENCE

f-stop: The reference for the aperture number that equals the focal length of a lens divided by the diameter of the aperture at a given setting.

Shutter Speed: The duration of time during which the shutter is open and the film exposed to light. Expressed in fractions of a second (example: 1/1000 second, 1/25 second, 1/16 second, etc.)

Left: Film release button, located on the bottom of the camera body. Right: Film rewind lever, on top left of camera body.

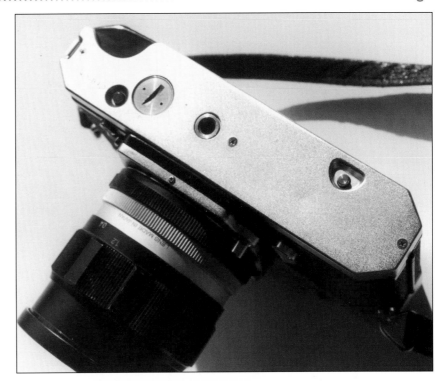

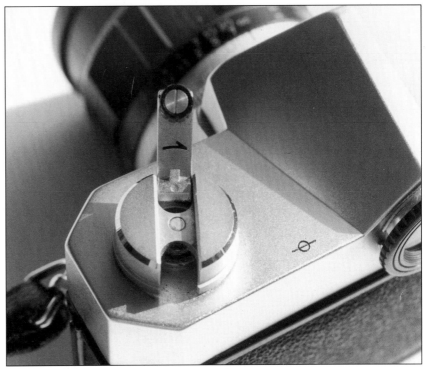

If your subject is not moving, select the f-stop with its built-in depth of field. Higher numbered f-stops require slower shutter speeds while lower numbered f-stops require faster shutter speeds. Your decision with the depth of field expresses your creative vision of what is and is not in focus and whether the action will be frozen or blurred.

• **Camera Flash.** Many SLR cameras contain a built in flash unit that may be used at will to automatically illuminate or flash

Simple model tripod.

fill in shadows. The camera's viewfinder will signal when it is necessary to do so. On manual SLR's, a battery operated flash unit may be attached to the top of the camera's prism which contains its flash connection. The manufacturer of the flash will require a shutter speed to be set at about 1/60 and a lens aperture to be set according to its focused distance.

• **Shooting.** Hold the camera firmly after setting the controls. Position the camera as you have selected for your composition. Stay still, elbows in. Slowly squeeze the shutter button being careful not to jar or shake the camera. No matter how carefully you focus and meter, camera movement during the shot will result in a blurry photo. Using a tripod is very effective for achieving a motionless camera. Using a fast shutter speed will also help minimize the impact of camera movement. If you do not have a tripod, try placing the camera on a sturdy surface and setting the camera's self timer.

• **End of film roll or mid-roll end.** At the end of shooting a roll of film (or if for some reason you want to develop the film before it is completed) you must rewind the film back into its cassette on the left side of the camera body. Some cameras have automatic rewind. Other cameras have a manual rewind. To perform manual rewind, press the film release button on the the camera body. The top numberless knob on the camera is the film rewind lever. Gently lift its lever and turn it clockwise until no tension is felt. The film is then rewound into its cassette.

Failure to completely rewind the film into the cassette will

result in the film being exposed to light when you open the camera back and will ruin the images you have shot on the film.

□ **Trial Roll**

The first experience with photography involves using the camera, exercising all of its controls, and taking various photo compositions.

• **What to Photograph.** Anything and everything in your world. Your vision is personal and unique. Show the way you see your world. Show how you see the world with your choice of subjects, beautiful or not, unusual or special. But be careful about showing the cliched images that we have all seen so many times that they have little meaning. You may take a picture of your Aunt Lizzie, but not as a snapshot that only has meaning to the relatives. Show us what is special about her, her look, smile, job, or peach preserves. Show us your cousin Roger and his pin-striped 1952 British motorcycle!

• **How to Photograph.** To begin, try to keep the horizon from tipping up or down in your first shots. Fill the viewfinder with what you are photographing. Empty space around your subject is usually not desirable. Experimentation will come later on.

Try to make every shot a simple composition as you will see on pages 24-30. This non-formula guide will insure that you always produce a successful visual composition – the basis of every two dimensional art work.

 # ASSIGNMENT ONE

Shoot an entire 24 exposure roll of 400 ISO B&W film, trying out the simple compositions (pages 24-30) with subjects that are that are close, mid range and far away. Shoot in bright sun and deep shadows and points in-between. Hint: If you are really trying to learn how the camera captures light and shadows, you may want to keep a record on paper (called a shot record) of the shutter speeds and apertures/f-stops of every frame. This record may then be consulted after the images are printed to learn what happened with the camera exposure and depth of field. A sample form which you can photocopy and use is provided on the next page.

Have your film developed at a local photo lab. When you get the photos back, compare them with the matching shot record. If the pictures are too light or too dark, check to see what your exposures were for that scene with the particular lighting conditions. Did you set the correct shutter speed and

"...you may want to keep a record on paper..."

SHOT RECORD

ASSIGNMENT TITLE: _____

DATE: _____

Frame #	Shutter Speed	f-stop	Description
1			
2			
3			
4			
5			
6			
7			
8			
9			
10			
11			
12			
13			
14			
15			
16			
17			
18			
19			
20			
21			
22			
23			
24			

Comments: _____

f-stop? What about the focus and depth of field? Again check the shot record to determine if you selected the correct f-stop and shutter speed combination. This comparison should inform you of how successful you were in the technical settings of the camera as well as displaying your unique compositions.

MORE FIRST SHOT PROJECTS

• Shoot entire rolls with pre-selected f-stops (all at f-16, all at 5.6, all at 1.8, etc.). Keep shot records. Compare the developed photos with the shot records to learn more about depth of field.

• Shoot entire rolls at pre-selected shutter speeds (all at 1/1000 second, all at 1/60, all at 1/4, etc.). Keep shot records and compare to developed photos to learn more about shutter speeds.

CHAPTER 2
Composition

☐ Learning to See

Photography is the study of light and much more. It is an extension of human vision integrating the latest state of the art technologies with a deeply personal vision. With photography we see light years ahead as well as seeing directly into ourselves. We learn to extend and expand our sight and insight not by cameras and lenses but by their creative use. How we understand and appreciate a photograph is based on its subject and its composition.

In photographing, we use the camera, take the picture, develop the negatives and make the print. But before all this, we See, we Observe. We recognize a grouping, an order, an arrangement existing in our field of vision. How images appear, combine, catch the light and make shadows provide endless opportunities for our personal insight and delight. The creative process of seeing has primarily to do with the visual arrangement of objects and spaces with all of their glorious lights and shadows. This is more commonly known as composition.

☐ Composition

Our personal vision is a complex interaction of perception (how our minds make visual order), psychology (what our personal histories bring to interpreting the subject) and the mechanics of vision (how our eyes see or make a picture).

Our most direct internal and external response to our world is through the camera's viewfinder. The viewfinder can easily be taken for granted, but you can elevate its simple mechanical function and turn it into a creative tool that does not simply contain or frame what you see, but channels your vision. The viewfinder is a creative tool that goes beyond simply finding and isolating a scene. The viewfinder presents us with four sides

> "... turn it into a creative tool..."

QUICK REFERENCE

Composition: The arrangement of visual elements in a photograph in respect to the effectiveness of the whole image.

Examples of a poorly centered photograph (top) and a successfully centered photograph (bottom).

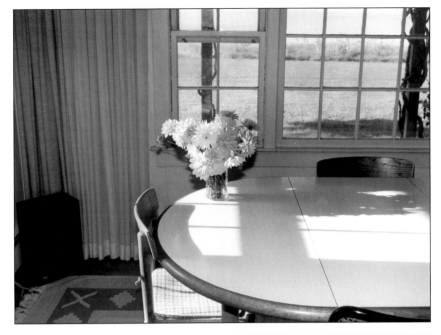

"... use the full potential of the rectangle..."

or edges to contain our selection, four sides on which are based all of our visual ordering and analyses. It is literally our frame of reference. Whether we use the viewfinder to "find" our compositions in reality or use it to "create" our compositions in a studio setting, we are utilizing it as our frame of reference.

☐ Types of Composition

It is suggested that we use the full potential of the rectangle or rectangular picture plane as seen through the viewfinder. This means avoiding cliched formulas of composition. It also means better use of the centered composition, a common photographic technique in which the subject is placed directly in

the middle of the photo. A centered composition works well when the subject is interesting and completely fills the entire picture with almost no other images seen in the background.

The centered image is a target and is an intended visual assault on the viewer. Because it is so blatant, it results in an image that is total in its intent. But our level of appreciation is much more complex and sophisticated than to always accept a centered composition.

Not all images can or should be centered. Other images combine to complicate the picture. Foregrounds and backgrounds add dimension, and other subjects on the same plane offer visual competition or collaboration. The richness of contemporary composition has been expanded directly because of the photographic image itself.

From its inception, photography has offered the world new ways of seeing that we immediately adopted and now claim as the defining format of compositional presentation. The inherent qualities of photography are now accepted compositional styles. Framing, cropping, f-stops, shutter speeds and the resultant depths of field have given us new compositional types. Images that are touching sides, off sides, overlapped, off centered, transparent or seen from a different angle have given us a new visual vocabulary. Light makes recognizable shapes, lines, textures and shadows. The viewfinder finds or displays images that touch or cross its frame or edges. And we may photograph images in front of, along side of or superimposed within the viewfinder. The number of different possibilities is virtually limitless! Seen this way, our photographs become personal instances of creative vision, individual and unique images that transcend formulas.

☐ Basic Compositions

There are seven basic compositions which have given us a new visual vocabulary. Compositions may be one of these seven types of compositions or contain elements of two or more types, resulting in a visually enriched photograph. They are:

1. Centered composition. The central image entirely fills the photograph with very little or none of the background. This composition may contain any or all of the following varieties of compositions (see previous page for example).

> "Not all images can or should be centered."

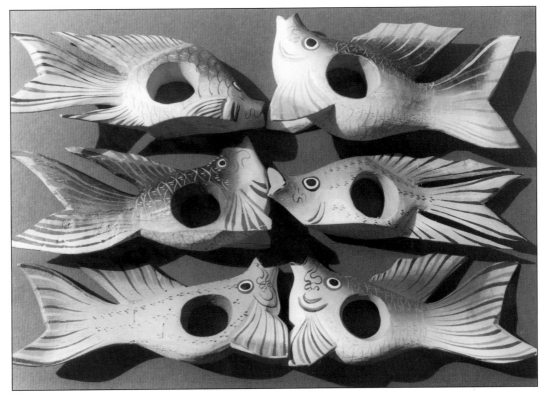

2. Touching sides. Objects in the photograph touch any or all of the four sides of the viewfinder or photographic print. The basic illusion of objects in reality touching is conveyed through the objects in the image being connected to the real sides of the photograph. It is the anchoring of illusion to reality.

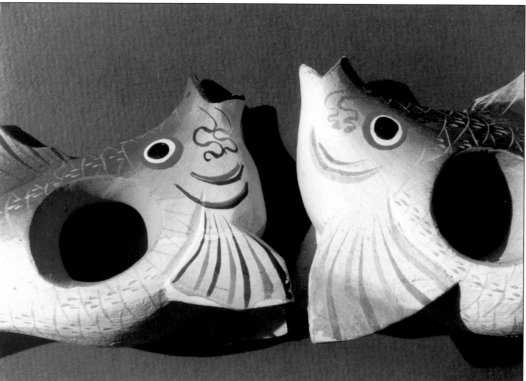

3. Off sides. Images in the photograph are cut off or cropped by any or all of the photograph's four sides. In this way, photography can slice through the illusion of reality by showing only a portion of what would normally be seen by the human eye.

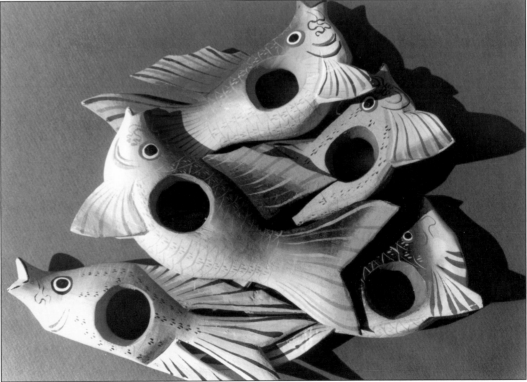

4. Overlapped. Objects in the photograph are displayed in front of and in back of each other. By providing a partial view of several different layers, this type of image creates the illusion of depth.

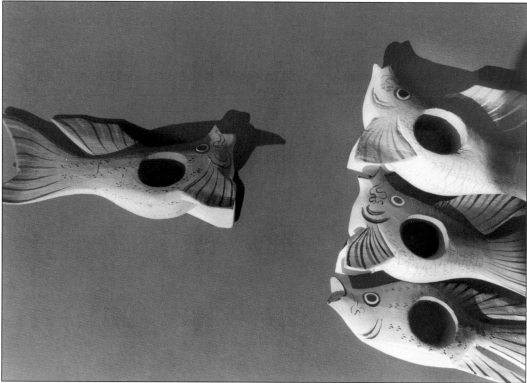

5. Off centered. More objects appear in one part of the photograph than in another section of the print. This imbalance within the field of view creates a system of visual comparison that moves the viewer's eye back and forth between the uneven portions of the image.

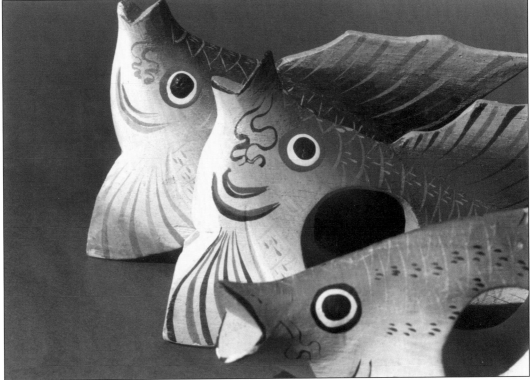

6. Different angle. These types of photographs display unique angles of vision. They directly convey the photographer's personal angle of confrontation and lend themselves to communicating a greater sense of the photographer's subjective expression.

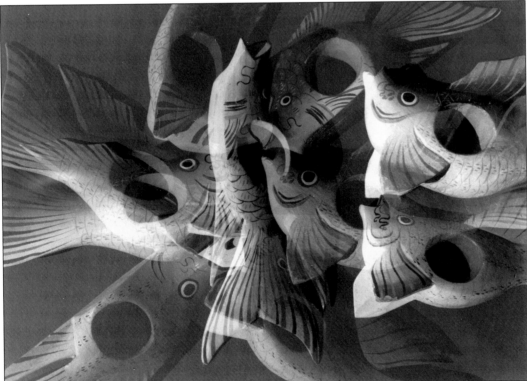

7. Transparent. Subjects are rendered see-through by a photographing technique. This procedure of multiple exposure transforms reality.

ASSIGNMENT TWO
LANDSCAPE EXERCISES

In landscape photography, what we are trying to do is to establish a sense of place – the what, when and where of that place. Discovering that special place and a unique angle of view is up to us as visual explorers. Determining when to photograph that place gives the image a special visual character. Photographers will revisit a location many times in different seasons, times of the day and weather conditions, exploring the multiple images that can be obtained from a single space.

"...multiple images can be obtained from a single space..."

☐ Assignment: Landscapes

• **Select and shoot landscapes** that display your choices of time and season. It is OK to include man-made structures for a sense of scale, but keep them subservient to the natural terrain.

• **Just for fun,** try creating a mini landscape. Arrange any locally available small natural materials within your selected landscape. Stones, leaves, twigs arranged by the local stream make for character-filled landscape compositions.

• **Spend some time** photographing landscapes from your pet's angle of view.

• **Photograph a circle panorama landscape** by placing your camera on a tripod and taking a number of shots in a full circle at the scene. Mount and display all the photos together.

☐ Landscape Tips

• **Lenses.** Much has been correctly and incorrectly written about the choice of lenses when shooting landscapes. The truth of the matter is that whatever lens you use, it is your artistic eye that selects the particular angle of vision to be photographed. Whether you favor the broad vistas and pushed back sense of space that wide angle lenses give you, or you prefer the tight and close angle of vision of telephotos (where the background gets very close to the point of focus), it is your call. Just about any lens may be used to shoot landscapes.

• **Panoramics.** Panoramic photos or photos that are much wider than high may be created in the camera if it has a panoramic masking device or in the darkroom by simply cropping. False panoramas use a standard angle of view lens and are later cropped, while a true panoramic photograph is made by using a wide to super-wide angle lens, and then cropping the image in the camera or darkroom.

A list of recommendations for photographing traditional landscapes is as follows:

1. Look for the light. Light defines space, texture and forms by creating highlights, shadows and all shades in between. Light should not be an obstacle to photography, but rather a tool for composing fantastic images.

2. Try to get near, midrange and far distances in the same photo. By doing so, you can create the illusion of space in an image.

3. Make compositions. All of them! Hold the camera vertically as well as horizontally. If a natural frame of leaves, openings in rock formations or clouds occur, use them as natural borders in the photo.

4. Experiment. Shoot different angles. Look for patterns. Get in very close and abstract from nature. Show us something different about the scene by using different lenses and other accessories.

The images on the following pages are all examples of successful landscape photographs. As you look them over, pay attention to the aspects that attract your eye as well as the compositional elements that contribute to the overall effectiveness of the images. By doing so, you can use this knowledge to achieve the impact and expressiveness of your creative vision.

"...create the illusion of space in an image."

Below: Mt. Everest in the clouds, Nepal.
Opposite, top: Living Rock, Petra, Jordan.
Opposite, bottom: Victoria Falls, Zimbabwe.

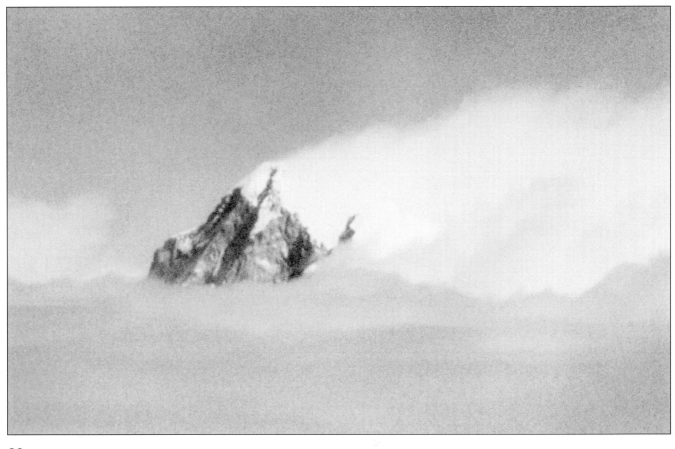

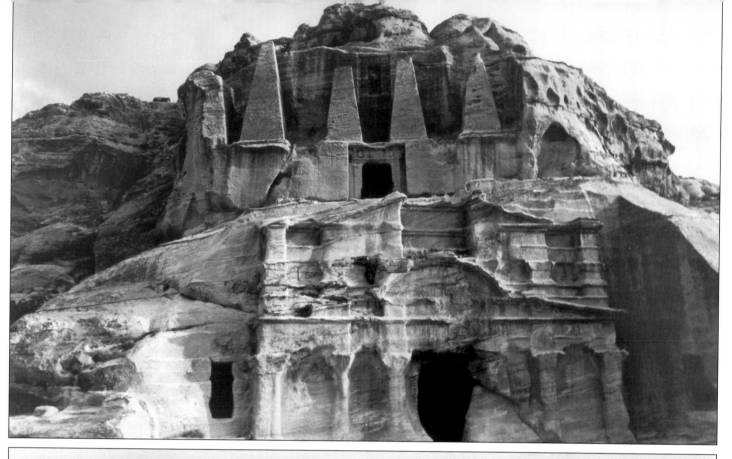

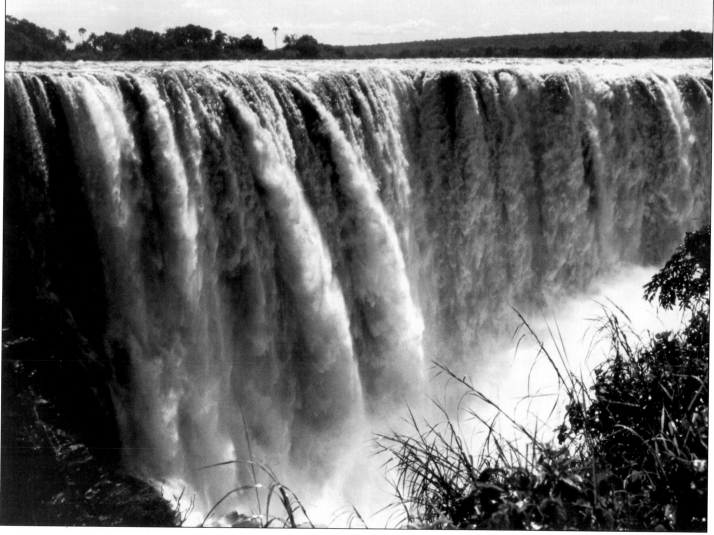

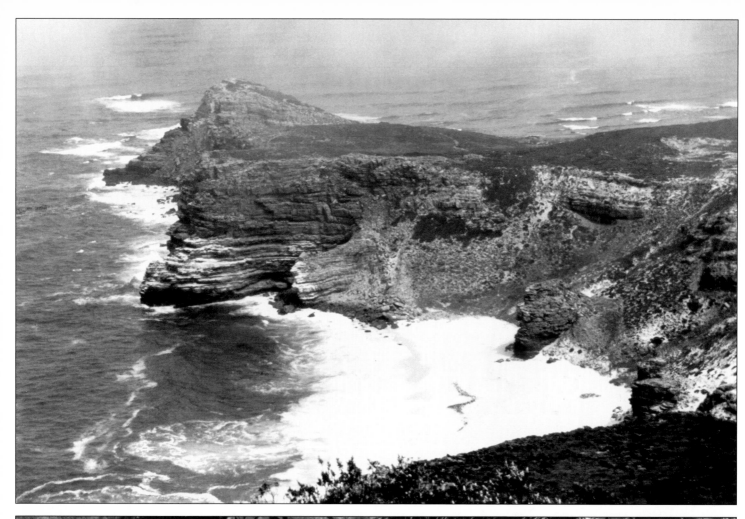

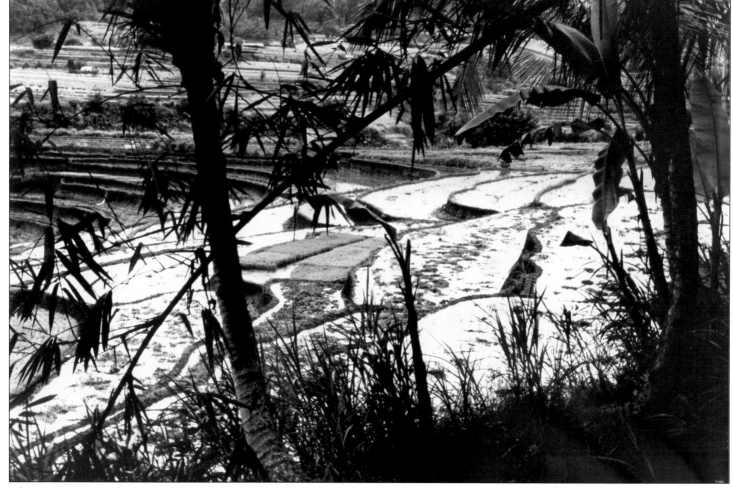

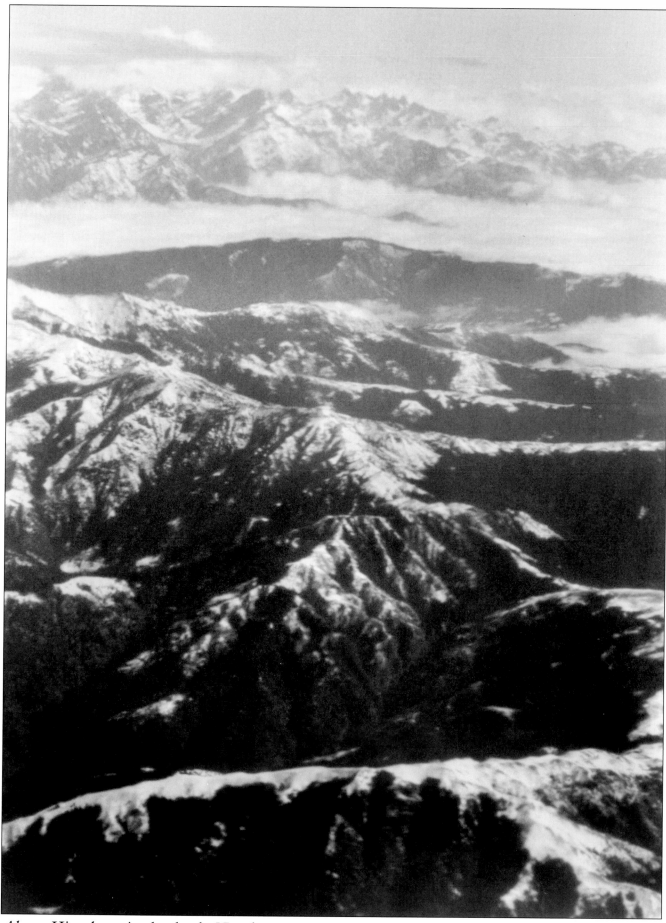

Above: Himalayas in the clouds, Nepal
Opposite, top: Cape of Good Hope Point, South Africa
Opposite, bottom: Rice Steppes, Bali

CHAPTER 3
Light and Shadow

☐ Intensity and Direction

The word "photography" is derived from the Greek words "photos" (light) and "graphein" (writing or recording) All existing light may be represented with its two basic descriptors: intensity and direction.

• **Intensity.** Very few objects have their own source of light. Most of the visible word relies upon light falling upon it to illuminate it and make it recognizable. The primary source of this illumination is, of course, the sun. The intensity of light is its brightness or diffusion. Photographers have a heightened sense of recognizing the various qualities of existing light. In fact, photographers' unique styles are distinguished by their preferred use of light.

How many different intensities of light exist? That all depends on how high you'd like to count. From the extremely aggressive, scorching African desert sun at midday to the barely recognizable final soft rays in a winter drizzle, there are countless levels of intensity of light. As you may have surmised, another way of describing the intensity of light is determined by your location, season and time of day. Recognizing the quality of the light will add a unique character to your photographs.

What are the "best" intensities of light in which to photograph? There are many. Although some seem to be better, the specific conditions of each category of photography should be considered. Nevertheless, every intensity of light does demand certain camera controls. Being aware of the qualities of the light is the photographer's primary concern.

• **Direction.** With your careful study of the intensities of light, you will certainly discover that there may be multiple or reflected light sources. There is light and there is reflected or bounced light. With this realization comes the fact that every

"...qualities of the light are the photographer's primary concern..."

light source has a direction. The position of the origin of light is important because it determines the "look" of the image. The angle of light causes both highlights (the most brightly lit parts of the object) to form and shadows to be created exactly opposite the highlights. How high or low the light is will determine how much of the objects being photographed are visible as well as the resulting size of the shadows.

□ **Shadows**

The direction of light creates highlights, midlights and, most importantly, shadows. Shadows are what give volume and form to lighted areas. Without shadows there is no form, no recognizable images as we know them, only streaks of abstract light. After looking for the light, the secondary principle of photography is looking for the shadows. Shadows are very important to the image not only because they define the objects but also because the shadows themselves are considered part of the photographic composition. Every fine photograph utilizes shadows as an integral part of its composition. Train yourself to observe shadows as well as light.

□ **Other Light Sources**

Of course, other light sources exist for the photographer besides natural light. We may utilize any of these sources of light, including airport lights, theater lights, ordinary household lights, flashlights, fireworks, candles or photo flashes in any of their widely varied forms. All of these artificial sources of light are also defined by their intensity and direction.

> "Train yourself to observe shadows as well as light."

ASSIGNMENT THREE

WHITE ON WHITE AND BLACK ON BLACK EXERCISES

For this assignment, we will be creating and photographing still-life compositions of all white objects on all white backgrounds (Part One) and similar compositions using black objects and backgrounds (Part Two). This assignment is intended to help you better understand how to creatively use the camera's built-in light meter, as well as to give you an opportunity to practice basic composition, arrangement and photography.

□ **Part One: White on White**
• **Procedure**
1. Collect five or more white or off-white objects and a few white backgrounds. Five objects or more will insure a variety of

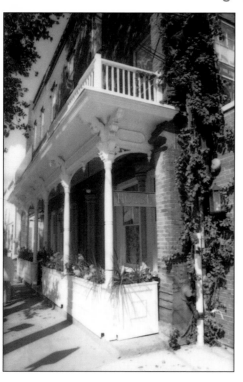
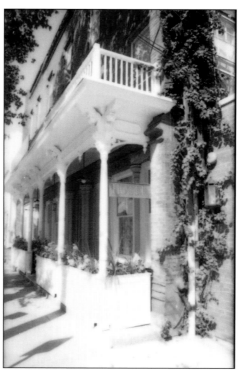
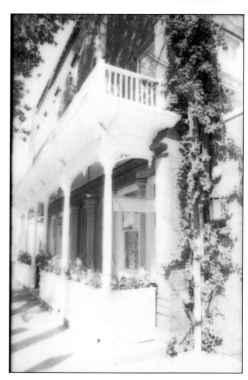

compositional possibilities. Either outdoors or by a window with direct light coming in, set up a white background with white objects arranged on it. The objects and backgrounds may but need not be related in any way in terms of theme, size and so on.

2. Stop and look at the composition. Your goal here is to create an arrangement of objects and backgrounds that includes both light areas and shadows.

3. See if the objects touch each other or not. See where they cast shadows and interact with other objects and the background. Notice the angle or direction of the light source. You may change the arrangement to capture the direction of light that you desire. If you have artificial light sources, you can substitute them for the light outdoors or coming through the window. You may want to use two light sources, carefully placing them to achieve a maximum of light and shadowy areas.

• **Lightmeter.** Frame your composition in the camera's viewfinder. Take a lightmeter reading by moving so close to the main subject that it completely fills the viewfinder.

Most 35mm cameras have a center weighted lightmeter that tries to make everything that it sees 18% middle gray. In other words, the camera shows all 100% white objects as a dingy 18% off white – not what we want. We must manually compensate by opening up the lens to admit more light. This procedure is called exposure compensation.

Above: Photographs showing the results of exposure compensation.

QUICK REFERENCE

Exposure Compensation: Changing the exposure to offset the averaging effect (averaging to 18% middle gray) of the light meter. This is often necessary when shooting very dark or very light subjects.

To do this, you must lower the f-stop numbers. For example, if your initial reading was f-16, opening the lens 1 stop would make the setting f-11, which is the next lower number on the lens. Two stops lower would make it f-8. Any kind of exposure compensation allows you to keep the shutter speed.

All white situations, such as snow scenes or bright beach scenes, require exposure compensation in order to achieve a more accurate rendering of the subject. The extreme light end of the spectrum is beyond the measuring capabilities of the lightmeter, so manual exposure compensation is necessary. Exposure compensation is an optional creative control in personalizing the image. The recognition of a light filled scene signals an opportunity to perform exposure compensation.

NOTE: If you are using a very advanced camera with a segmented meter, you already have exposure compensation built into its program. Read your camera instruction book for the exact specifications. If you switch to a center weighted or spot meter, then you may manually control the exact amount of exposure compensation you desire.

• **Shooting.** With the still life arranged, lighting established and composition considered, frame the shot. Walk up close and take a lightmeter reading. Note it. Recompose and shoot one frame with the reading the lightmeter states. Take another shot of the same composition at +1 compensation (one f-stop lower). Take another shot with a +2 compensation (two f-stops lower). And finally take a third shot of the same composition with a +3 compensation. If you are in doubt what the next lower f-stop number is, look down at your lens. All the numbers are displayed on the f-stop ring.

What you have photographed will represent a tonal range from which to select in making a print. Most photographers choose an exposure that is closer to +2 or +3 in order to produce cleaner, bright whites. Other f-stops will be darker and convey a moodier appearance. At this point, you can experiment with exposure compensation as a way of getting a feel for how different settings affect your photographs. Have your pictures developed at an outside lab and then use your shot record to observe the results of this experimentation. (In Section Two, you will learn how to use this procedure to create a test strip, which is an exposure series on a single piece of photosensitive material. A test strip allows you to evaluate your images before you make a final print.) Gradually you will learn how to recognize situations where exposure compensation is necessary without having to rely on a test strip. For now, shoot as many rolls as you can and acquaint yourself with how your camera's settings can be used to get the most effective images possible.

"...use your shot record to observe the results of this experimentation."

MORE WHITE ON WHITE PROJECTS

• Try shooting compositions in the same manner as the white on white images, but use other colors (yellow on yellow, red on red, etc.) to learn how to control the gray tonalities in different color mediums.

The photos on the following pages are examples of white on white images. They represent a variety of compositional styles and can serve as references as you attempt both the assignments in this book and your own experiments.

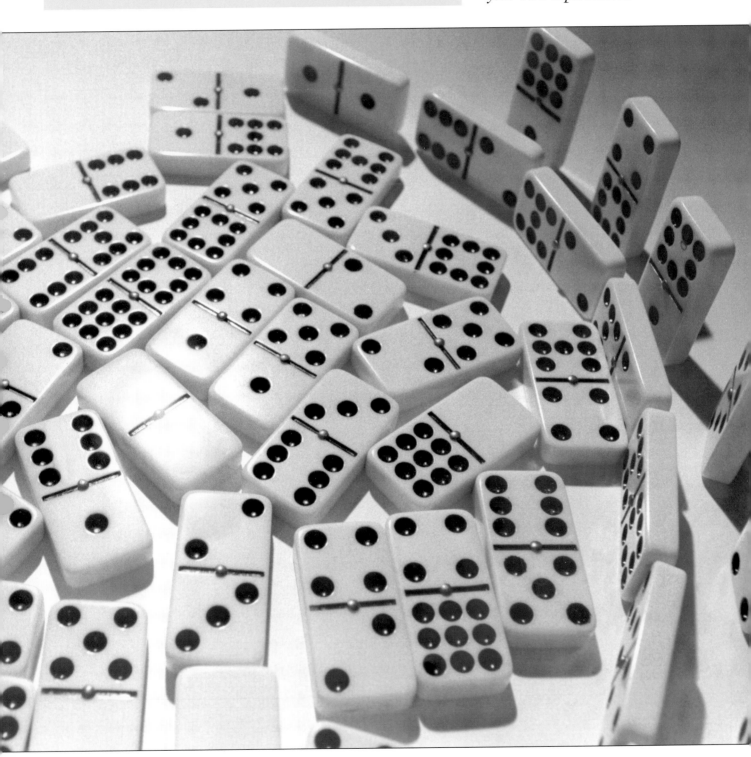

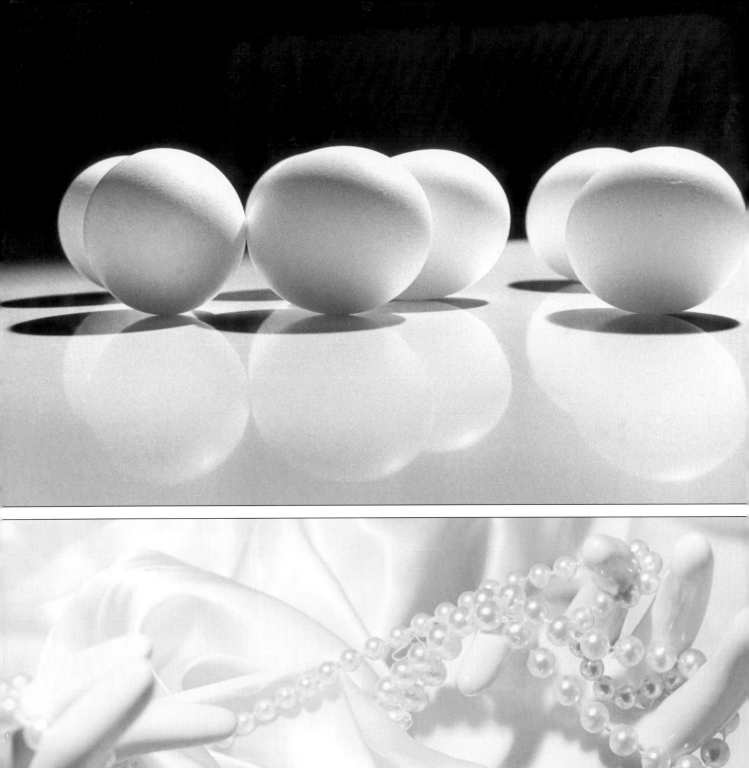

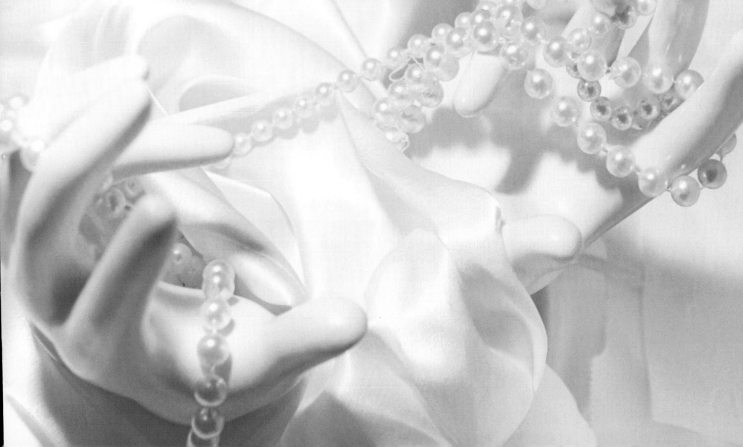

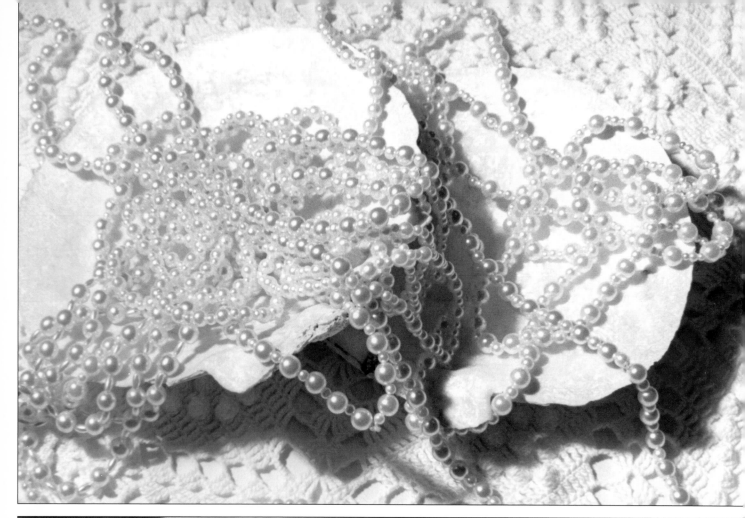
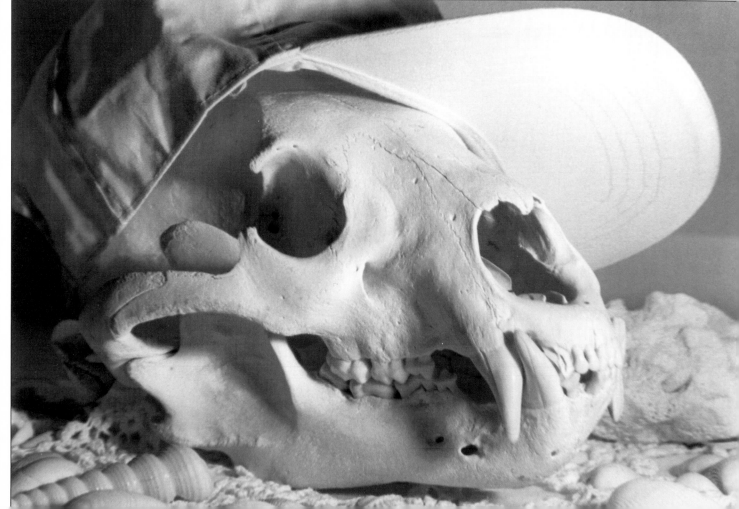

☐ **Part Two: Black on Black**

Here's another sophisticated camera assignment for which you must use exposure compensation, but this time in order to adjust for the other end of the spectrum. The same technique is necessary when dealing with shadows. A camera's lightmeter tries to make everything within the shadows 18% gray. So instead of 100% pure black, the lightmeter will make it 82% charcoal gray. Again, this is not usually what we want.

• **Composition.** Collect five or more black or very dark objects and backgrounds. Three or fewer objects makes composing a still life more difficult. Remember that black and white panchromatic film cannot see colors but records them as shades of gray. Arrange your composition and light it in the same manner as the white on white assignment.

• **Lightmeter.** Take a lightmeter reading in the same way as the previous project. Note it. Now you will perform exposure compensation, but in the opposite direction of the last assignment. This time you will lower the amount of light in order to darken the subject. For example, if the reading is f-5.6, a -1 exposure compensation would close down the lens to f-8. A -2 closedown of the lens would be f-11. And a -3 f-stop closedown exposure compensation would result in a setting of f-16.

• **Shooting.** Take the composed shots: one from the camera lightmeter reading; another one with a -1 exposure compensation; the third one with a -2 exposure compensation, and a final shot with a -3 exposure compensation. Have your film developed at an outside lab and then study the results.

QUICK REFERENCE

Panchromatic Film: Film that is sensitive to ultraviolet radiation and all colors of light. Panchromatic black & white film records all colors as varying shades of gray.

MORE BLACK ON BLACK PROJECTS

• Try photographing deep shadows in wooded areas or on buildings, using exposure compensation to learn more about metering and to push your compositions in different directions.

• Try creating a composition of black textures to learn how surface reflections can afford you opportunities to experiment with creative exposure compensation techniques.

The images on the next two pages are examples of black on black compositions. As with the white on white shots, these pictures illustrate several different approaches to this type of photography and can be used to help you gain a better understanding of this style. Use them as resources to which you can refer while you are attempting your own black on black experiments.

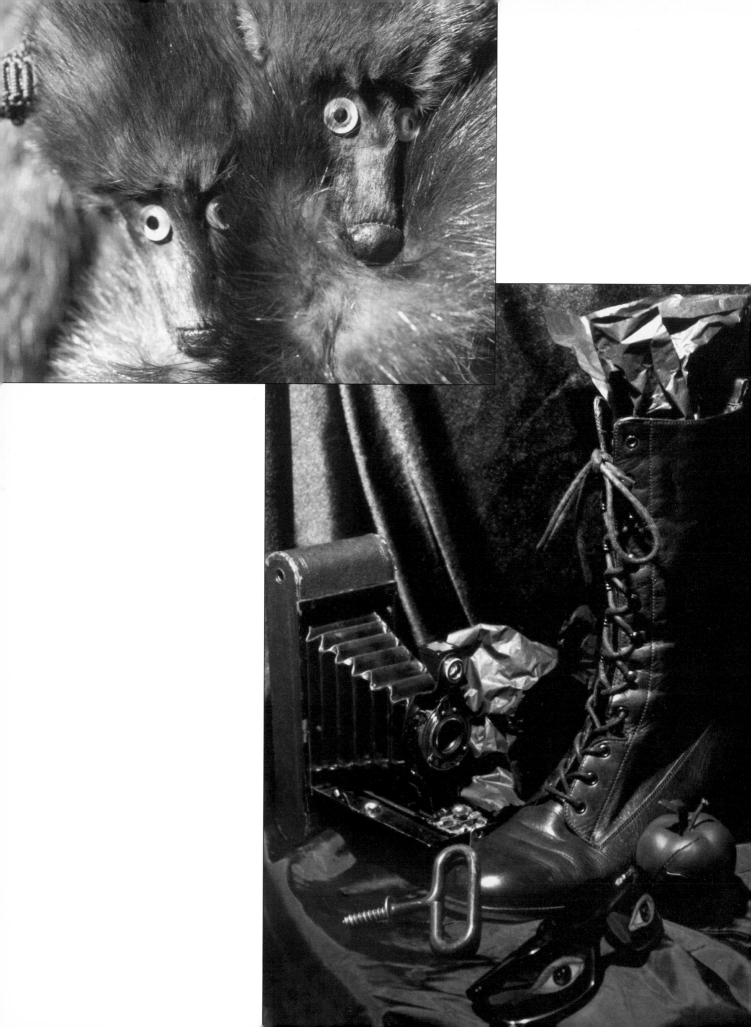

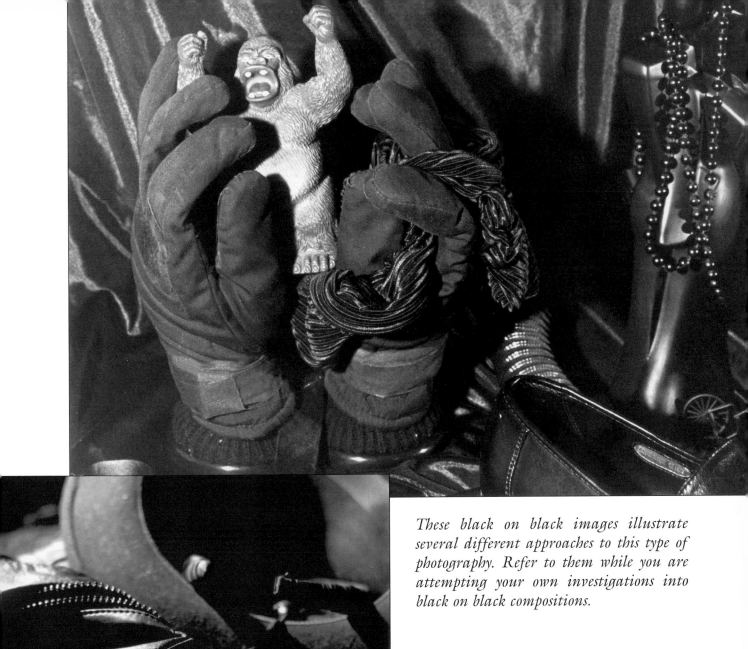

These black on black images illustrate several different approaches to this type of photography. Refer to them while you are attempting your own investigations into black on black compositions.

CHAPTER 4
Film

All photographic film, regardless of its size, is simply a piece of celluloid (called a base) on which is sprayed a light sensitive chemical, usually containing grains of silver halide. There also are two or more protective coatings.

| Scratch-resistant top coating |
| Light-sensitive emulsion |
| Film base |
| Anti-halation coating |

Left: Illustration of the layers that make up photographic film.

In essence, light coming into the camera through the lens strikes the film and "tarnishes" the grains of silver halide. The film developing process permanently sets those patches of tarnished grains on the film and washes away the unexposed grains, leaving an inverted image that is more commonly known as a negative.

Below: An example of a normal (positive) image and its negative.

Only 35mm size film is usable in a 35mm camera. No other size of film will properly fit in the camera. Rolls of 35mm black and white film are available in 24 or 36 exposure cassettes. It is recommended that beginning photographers who will be doing their own film development use the 24 exposure size. It is simply easier to handle. A popular misconception is that only certain cameras use black and white film and only others use color film. This is not so. All cameras will shoot both varieties and others as well. Color developing and printing require special color chemicals and procedures, of course.

The most important characteristic of film to know is its speed, which is called its ISO followed by a number. ISO is an acronym for the International Standards Association, who assigns a number to film based on the amount of its light sensitive chemicals. If you are using an older camera, the ASA (America Standard Association) and its number is used in place of the ISO. It is the same number. The higher the ISO number, the faster the film records light and the faster the camera may catch the action. The slower the film, the more detail may be captured but the slower the shutter speed. Faster film shows more grain in the photograph. Slower film shows less grain in the photo.

> "The most important characteristic of film to know is its speed..."

Above: The image on the left shows little grain and has a clear, smoothed appearance. The image on the right shows more grain.

Many manufacturers produce fine quality black and white panchromatic films in ISO speeds of 25, 50, 100, 125, 400, 800, and up. These films are available in the traditional silver halide grain chemistry or in the new T-grain chemical technology which produces very fine grain images but requires more attention to film development. Chromogenic black & white films produce black & white photos using color chemicals, and even the popular one-hour photo shops can process this film.

Always check the film box for its expiration date and keep film in a cool dry and dark place. The refrigerator will not keep film appreciably fresher than its expiration date. If refrigerated, the film requires one to two hours in its closed container to return to room temperature before using.

Film manufactured in the USA is considered prime quality and dependable. Film manufactured in different countries (called gray film) is not considered dependable by professional photographers.

> "Always check the film box for its expiration date..."

☐ Motion

When photographing, it is possible to capture (stop) the action on film with crystal clarity as a frozen moment in time, or create a blur in the subject or background that gives the illusion of movement. The choice is yours depending on the speed of the action, speed of the shutter, speed of the ISO and the amount of existing light.

Below: Stop action photograph of a swan attacking a goose. Note the blurred portions of the birds' bodies and the frozen droplets of water.

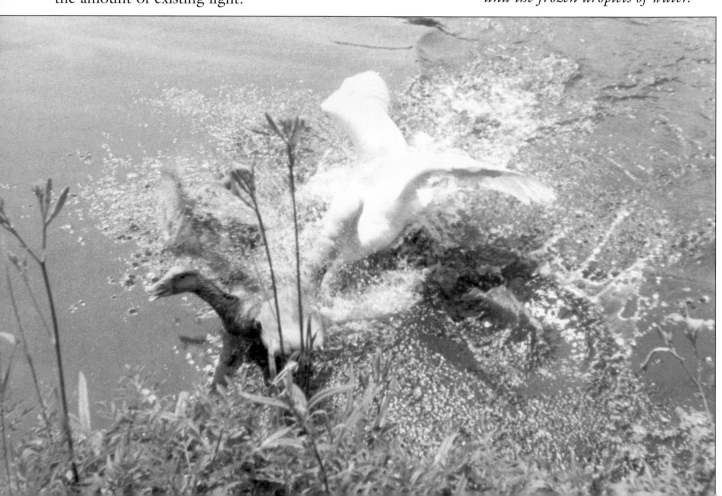

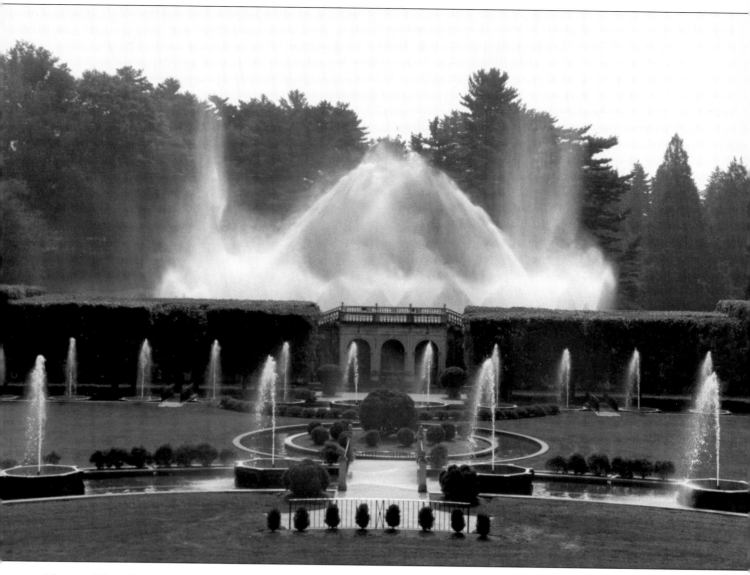

Above: The Dancing Fountains, Longwood Gardens. Note that the water appears to be in motion while the surrounding fountains and gardens are focused.

• **Stop Action.** In shooting any photographs illustrating motion, action or speed, it is necessary to pre-set the camera and lens. Decide what action to photograph, select a high speed film like ISO 400 or higher to use, and then select a fast shutter speed. Traditionally, 1/60 is normal, 1/125 will stop most human action, and 1/1000 will stop the propellers of an airplane. Set the selection on the camera's shutter speed control wheel or digitally.

Determine the lighting conditions and pre-set the lens for its required aperture for the correct exposure. Some photographers also try to pre-set the focus. Position yourself for the action and shoot.

• **Subject Blur.** To create the illusion of a subject in action, shoot slowly, with a slower shutter speed. Slower shutter speeds like 1/60, 1/30, 1/15 or slower will then create a blurred subject but not the background. Use a tripod to insure clarity of the background. Keep the camera pointed straight ahead and focused on the background allowing the subject to move in front of the camera while the picture is being taken.

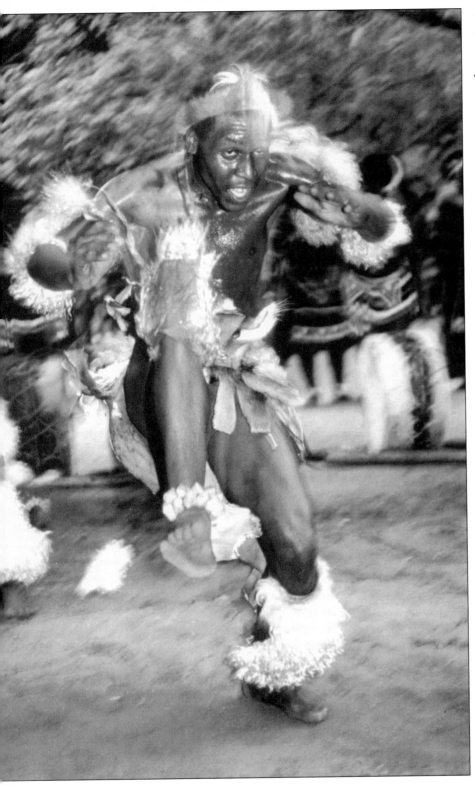

Left: Zulu Warrior Dance, South Africa. The warrior is frozen in the midst of his dance, while the background is blurred.

•**Background Blur.** If you wish to capture or "freeze" the subject in action but blur the background, pre–set the camera and lens controls for a fast shutter speed, focus on the subject and shoot panning (following the action while taking the picture). It is important to follow the subject at the same rate of speed that subject is moving.

ASSIGNMENT FOUR

MOTION

Photograph "frozen" action by using a fast film and shutter speed. The action may be simple or complex, human, animal, natural or machine. You may direct or choreograph motion for dancers or children (who make wonderful subjects). Try to get close enough to what is happening to fill the viewfinder (so long as it is not threatening or dangerous). Mastery of this assignment requires some practice working with the rate of speed of the motion you are trying to capture.

MORE MOTION PROJECTS

• Create examples of action, such as feathers falling or kids splashing in a puddle. Shoot at fast shutter speeds and very slow shutter speeds. Print and compare.

• Try dancing and shooting with your camera or shoot while riding amusement park rides. Print and see the action blurs that you have created.

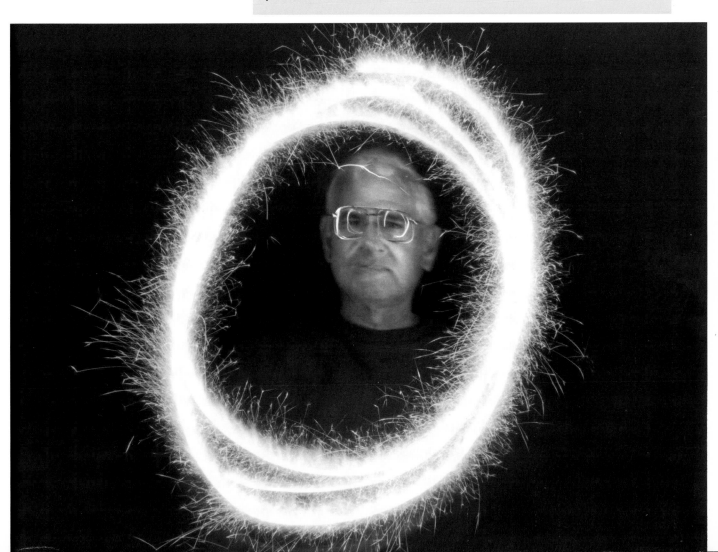

CHAPTER 5

Lenses & Filters

◻ Lenses

While it is true that the camera body does in fact record the light striking the film inside, it is also true that the lens controls the amount of light and angle of vision allowed to enter the camera body. Whether it is done manually or automatically, the lens will provide an angle of vision wider, equal to, or narrower than our vision. The f-stop determines the amount of light entering the camera and allows the camera's light meter to measure it. Most lenses indicate their focal range on the focusing ring (from infinity to the minimum focus distance allowed by that lens). Lenses also control the amount of perspective shown in the scene. Properly called the lens barrel assembly, they are composed of more than one piece of glass or high quality optically corrected plastic (called aspheric), in various combinations of concave and convex individual elements. Because of the various sizes and shapes of the lens' internal components, what is seen in the viewfinder is reduced enough to fit on one frame of 35mm film. Refer to the diagrams on pages 7-8 for illustrations of how light passes through a camera's internal assembly to create a photographic image.

The images on the following pages will give you a better idea of how different lenses and angles of view yield different perspectives of the same subject. The caption boxes contain two numbers: the first is the size of the lens (in millimeters), and the second is the angle of view (in degrees).

> "Lenses control the amount of perspective shown in the scene."

18mm, 100.5º

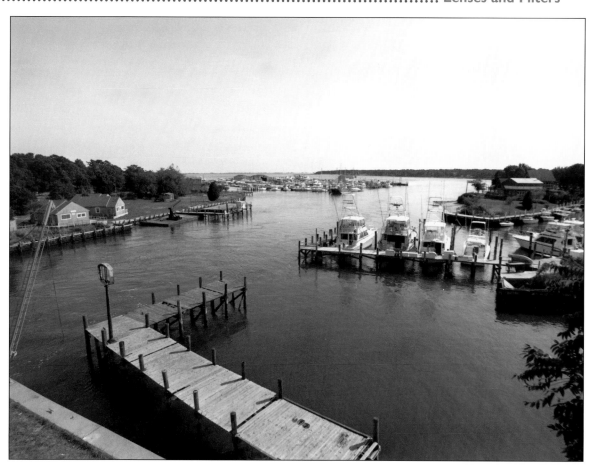

20mm, 94º

24mm, 84.1º

28mm, 75.4º

35mm, 63.4º

50mm, 46.8º

70mm, 34.3º

100mm, 23º

135mm, 18.2º

200mm, 12º

300mm, 8.2°

450mm, 6°

• **Amount of light.** The lens controls the amount of light allowed to enter the camera. This allows the camera's light meter to measure the intensity of the light. The lens' maximum, fastest or widest aperture (all the same) is that lens' widest opening. Other lenses will have different maximum apertures. The lens' widest opening or aperture is assigned its smallest number. The smaller the aperture size, the higher its aperture number or f-stop. Technically, the reason for the reversal of these numbers is based on the distance from where the light converges in the camera to the film plane. The principle on which lenses operate is based on the amount or intensity of light. The more and brighter the available light, the more the aperture closes down or gets smaller because it doesn't need so much light to strike the film. And conversely, the aperture opens up to admit more light in dimmer situations to register on the film.

Smaller aperture speed means less light reaches the film. More depth of field.

Larger aperture means more light reaches the film. Less depth of field.

☐ Categories of Lenses

There are basically four categories of lenses: normal; wide; telephoto and specialty. Each has its own characteristics of angle of view(or focal length) and the amount of light admitted.

• **Normal Lenses.** Photographic lenses see the same angle of vision as the human eye. There are no unusual changes in the angles that we see, no unusual changes in subject distances or perspective, and no curvature of vertical or horizontal lines in reality. In terms of 35mm lenses, those angles are considered normal focal length lenses and are designated from about 45mm to 65mm.

Top: Photograph using a normal (50mm) lens at a normal angle of vision.

Bottom: Wide angle photo using 20mm lens.

• **Wide Angle Lens.** As the name suggests, wide angle lenses provide us with a wider than normal angle of vision. Because of the internal components of the lens, the angle of vision is widened to let us see a broader panorama than we normally see. Two characteristics of wide angle lenses are: (1) The scene looks broad, but objects seem pushed back closer to the horizon, and (2) there is a change in what is termed photographic perspective, where the closer images to the camera appear larger in proportion to their backgrounds.

With ultra wide angle lenses, where the angle of vision is extreme, some distortions may occur. One type of distortion is known as barreling, where straight lines appear to be bulging out towards the edge of the picture. This may be considered a problem, especially in architectural subjects where straight lines are required.

• **Telephoto lenses.** There are many means for bringing distant objects up close: telephoto lenses, teleconverters and zoom lenses.

1. True telephoto lenses are lenses with longer focal lengths, from 105 to 1000mm or more. They narrow our angle of vision and magnify objects and scenes. Because of their lens design,

QUICK REFERENCE

Perspective: The apparent size and depth of objects within an image.

Barreling: The effect that causes straight lines to appear as curved lines.

these lenses seem to compress space between the object focused upon and its background. Photos shot with telephoto lenses show a shallow depth of field.

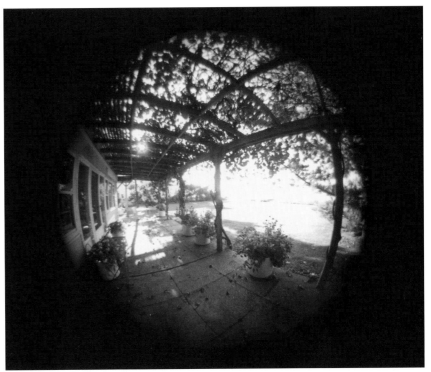

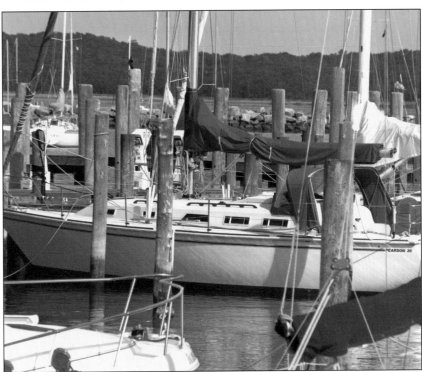

Top: Example of barreling. Note the curvature of lines that would normally be straight.
Bottom: Photo taken with telephoto lens (300mm).

2. Teleconverters are supplemental pieces of equipment that fit between the camera body and the lens that magnify the focal length by 1.4, 1.5 or 2 times. They increase the telephoto qualities of the lens with little additional weight or cost, but they do require an additional 1 to 2 f-stops or apertures. In other words, you must open up or widen the aperture in order to let in more light.

3. Zoom lenses are manufactured in every lens category as well as between two or more lens categories: wide to wide; wide to normal; normal to normal; normal to telephoto; telephoto to telephoto, and wide to telephoto. In essence, the zoom function includes a range of focal lengths. Zoom lenses contain all the characteristics of a number of single focal length lenses have but are constructed in compact single units which are heavier in weight than single focal length lenses but convenient to use. Zoom lenses called "macro zoom lenses" are not true macro lenses but do allow for a closer than normal minimum focus distance.

• **Specialty lenses.** Specialty lenses have a wide variety of specialized uses that distinguish them. Each has its own individual advantages.

1. Macro lenses have individual focal length lenses (60mm, 100mm, 180mm, etc.) and have the unique ability to get close enough to the object and photograph it so that the image on the film is exactly the same size that it is in reality. This is called a 1:1 ratio. Only a true macro lens will do this. Other telephoto lenses will allow close-ups at 1:4 or 1:2 ratio but not 1:1. These lenses usually have superior optics with special internal lens component designs to permit very close photography.

Above: A macro lens.
Below: Two photos shot with a macro lens. At right is a backlit iris, and at left is a wishbone with a few stacked coins.

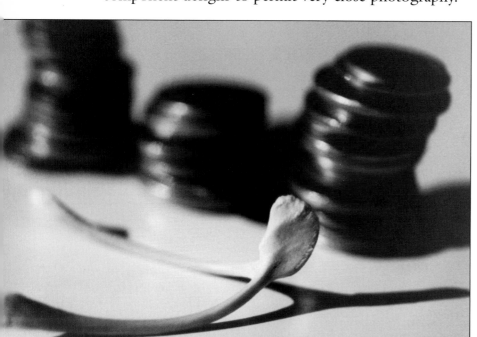

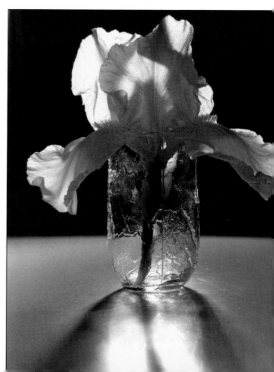

Right: Warsaw State Building, Poland, taken with a perspective control lens.

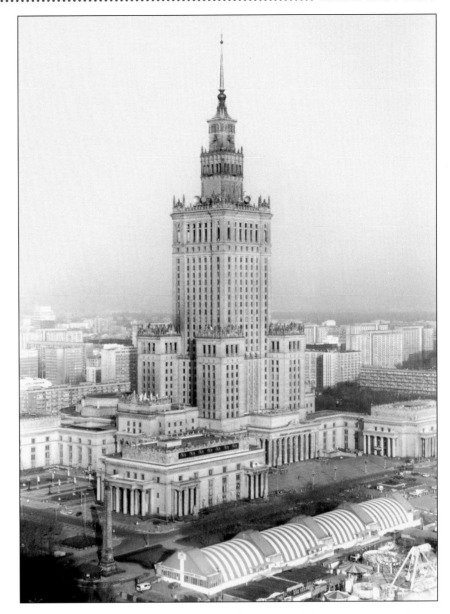

2. Perspective control lenses, which are sometimes called shift lenses, are manual lenses that "correct" the appearance of buildings slanting up and backwards in architectural photography. They do this by manually shifting the front part of the lens to compensate or correct the leaning appearance of buildings.

3. Fish-eye lenses are ultrawide angle lenses that can show an angle of vision approaching 180 degrees or complete half sphere. There are two types of fish-eye lenses: (1) the circular image kind that displays increasing distortion of objects as they approach the perimeter of the image, and (2) the rectilinear or squared off variety which frames the image in such a way that less distortion is visible. For an example of a photograph created using a fish-eye lens, refer to the middle image on page 42.

"Fish-eye lenses...can show an angle of vision approaching 180 degrees..."

☐ Filters

Black and white film records all the colors of the rainbow in many different shades of gray, from the gossamer pearlescent and palest off white to the sooty pitch tar pools of black. Black and white film is called panchromatic because it records all colors as varying shades of gray. It is possible to change the recording shades of the film by the use of filters which are screwed into the front of the lens. Because most 35mm cameras, if not all of the SLRs, contain a light meter that measures the filtered light automatically, there is no need to manually calculate and set the appropriate aperture.

Black and white filters perform many functions. They may be "stacked" on top of each other – but a word of warning here. More than three filters will probably soften the appearance of the printed photo. Also, the more filters that are stacked, the more likely that their stacked length will vignette or darken the edges of your print because they close in around the angle of vision of the lens. A lens hood that is too small for the angle of vision of that lens will also cause vignetting. Lens hoods provide the desirable function of blocking out flare or light directly striking the outside of the lens and creating streaks or very light, saucer-like marks on the film.

QUICK REFERENCE

Vignetting: Underexposing the edges of an image, sometimes done intentionally but also an unintended effect caused by a lens hood that is too small.

 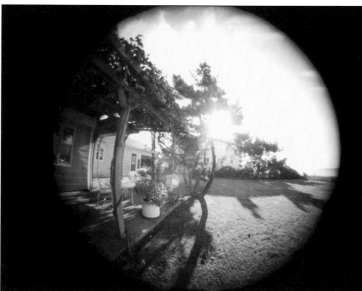

The size of the filter is printed on the front of the lens. Be aware that it is not always the same size as the focal length of the lens. The lens should be kept clean of dust, debris and finger marks. Use only special lens paper, brushes or micro cloths on both sides of the filter as well as the lens.

Above, left: An example of vignetting.
Above, right: An example of flare.

Below is a list of black and white filters and the effects that they produce.

Filter	Effects
Basic Filters – used to effect subtle changes to correct for glare, haze, etc.	
1A, 1B	Used only as a protection for the lens; no measurable effect
UV or Haze	Removes atmospheric or sky haze, usually at a distance
Polarizer	Removes highlights and reflections; tends to create more contrast; can steal an f-stop
Colored Filters – absorb their own color to a degree and deepen complementary colors	
Yellow 8 (Medium or Dark)	Makes all blues appear darker in the print
Orange (Medium or Dark)	Makes blues even darker than yellow filter
Red (Medium or Dark)	Lightens reds, turns blues to black; used for infrared photography
Yellow Green 11	Lightens light greens, slightly deepens reds
Green	Further lightens greens, blackens reds
Specialty Filters – create unique effects or add special abilities to the camera	
Close-up (+1, +2 or+3)	Permits the lens to get closer than the lens' minimum focal distance; may be used with color film as well
Soft focus	Create soft, somewhat hazy effect
Vignetting	Creates darker edges on an image
Star (cross-screen)	Causes rays of light to radiate from bright light sources
Kaleidoscope	Fragments subject into multiple reflected images

The photographs on the following pages were taken using several different filters. Note how they affect each image and then experiment with various filters and combinations to discover your own personal preferences.

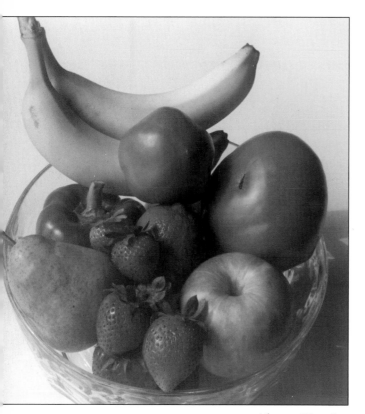 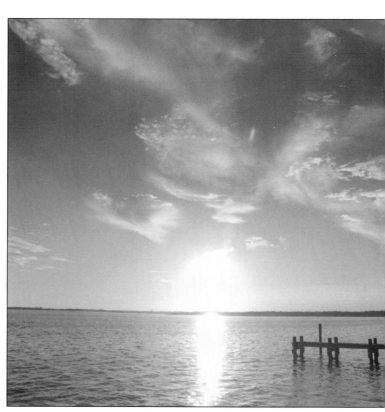

Above: Two images taken with no filter.

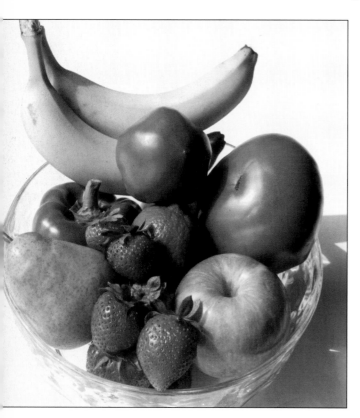 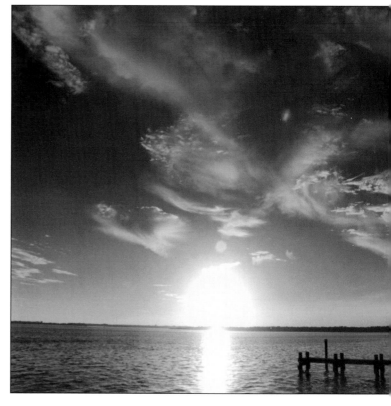

Above: Two images taken with with a yellow filter.

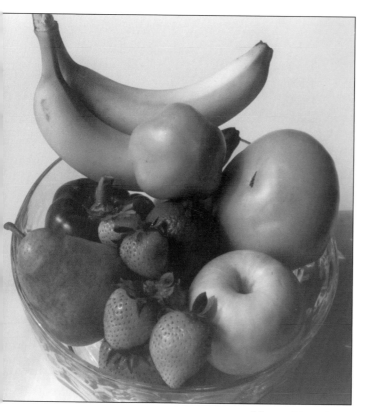
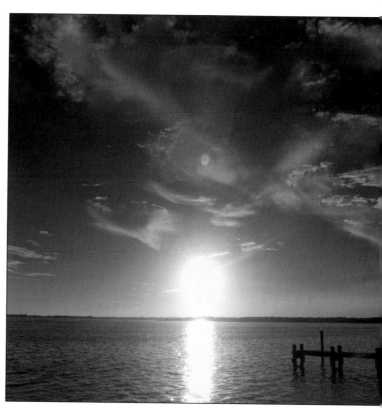

Above: Two images taken with a red filter.

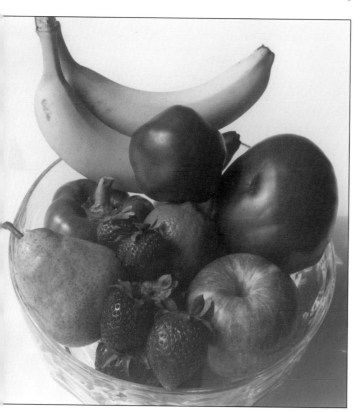
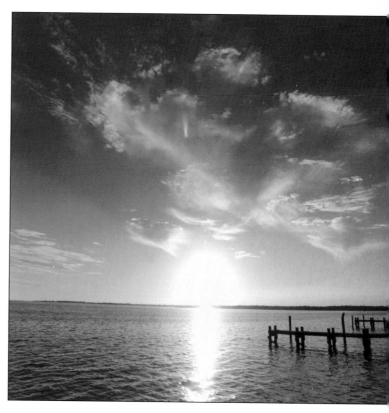

Above: Two images taken with a green filter.

ASSIGNMENT FIVE
Close-up Technique and Equipment

It is human nature to try to get very close to small objects, to flowers or to someone special. Lenses allow us to get an image that is the same size as the object we are shooting. In more advanced close up study, we can get closer than that.

This assignment lets you use your camera and lens for photographing as close as possible with them. You may also want to invest in a few other pieces of moderately priced photo equipment that will permit you to get a 1:1 ratio. Or, if you prefer, you can invest in the ideal: a true macro lens that will allow you to continuously focus down to a 1:1 ratio with superb clarity.

You can't get closer to the subject by using the enlarger to enlarge your negative. It will result in a larger, grainier photo but not in a closer one.

☐ Close-up Tips
Ways to get closer to the subject are:

1. Minimum focus. Every lens has a minimum focus which is usually stated in feet and meters on or near the focus ring of the lens. It will tell you how close that particular lens will focus. Anything closer than that will require additional equipment.

2. Telephoto lens on minimum focus. By itself, a telephoto will not allow you to get physically closer, but it will give the illusion of bringing the subject closer to you. This is more evident when the telephoto is used at its minimum focus.

3. Teleconverter. Connect the teleconverter between the camera body and the lens. It will multiply the focal length by 1.4, 1.5, or 2 times, making the lens a telephoto. It will steal an f-stop or two, which will limit your depth of field.

> "It is human nature to try to get very close to small objects..."

Below: 1.4x and 2x teleconverter.

4. Close-up filters. Close up filters are screwed onto the front of the lens and magnify the image, somewhat like a magnifying glass. They are available according to the manufacturer as +1, +2, +3 and may be stacked one on top of another to get even closer. As with most filters, the more you stack, the less clear the image will be. Close up filters may sometimes produce a softening of the image near the frame or edge but will not steal f-stops as teleconverters do.

5. Extension tubes. Extension tubes are metal tubes available in three sizes that are attached between the camera body and the lens. They will magnify your image without the edge softening effect that close-up filters produce. They also may be stacked on top of the other. They will not steal f-stops as teleconverters do.

□ **Assignment: Close-up**

This is a two part assignment. Part one uses a flat surface to photograph upon, and part two uses the same flat surface along with small 3-D objects. The objective of this assignment is for you to discover exactly how crucial the focus and depth of field become at a very close range. The closer you get to the subject, the more critical focus becomes.

Use a tripod or the self timer on the steadied camera. Try to get enough adequate light to shoot at the highest numbered f-stop on your lens. The closer to the subject the flatter or more compressed the depth of field. This does not matter that much with photographing a flat surface, but it matters significantly with photographing 3-D objects with shallow depths.

Part 1: Flat. On a firm piece of paper, create a flat surface collage or composition of cut-out photographic images of your own photos, drawings, magazines or newspapers, making certain that its final size will fill the camera's viewfinder at minimum focus. Select any of the five different ways to get closer to the subject and use it to photograph as many of the simple compositions that you can find or create. Try using both a low and a high f-stop. Print both and compare.

Part 2: 3-D. On the same collage, place at least four or five small objects of your choice. Light your composition, remembering that shadows which are cast due to the angle and intensity of light are part of the composition as well. Photograph it making as many compositions as you can from the combination of 3-D objects on the collage. First, shoot a high numbered f-stop, focusing on the background, then another at midground of the object and finally one shot focusing at the top of the small object. Develop and compare the very different effects that you have created.

"The closer you get to a subject, the more critical focus becomes."

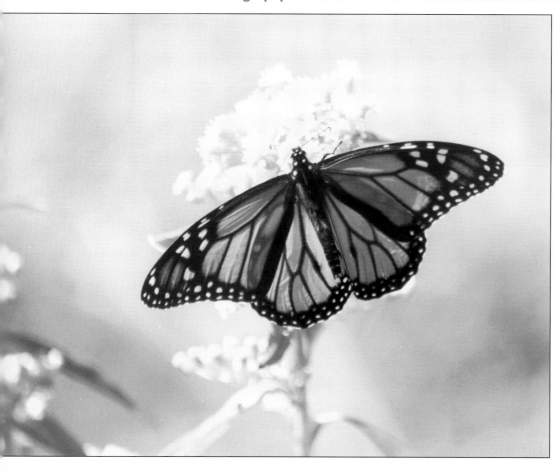

The images on these two pages are good examples of various close-up compositions. Experiment taking close-up photographs of different subjects to discover the many possibilities of this type of image.

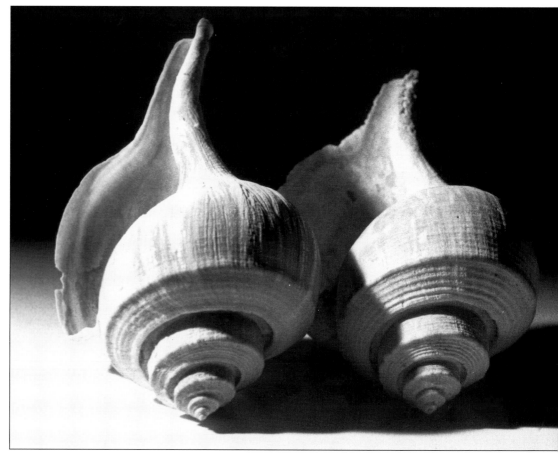

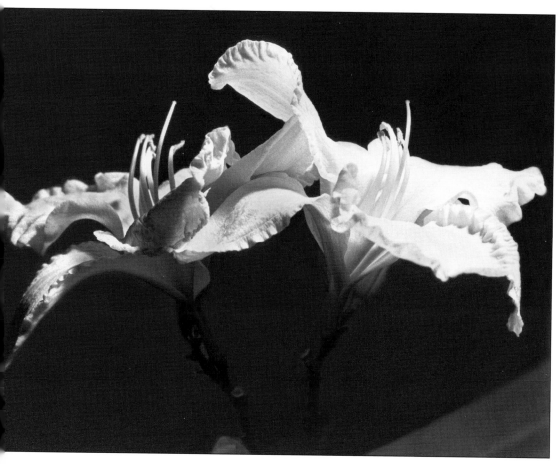

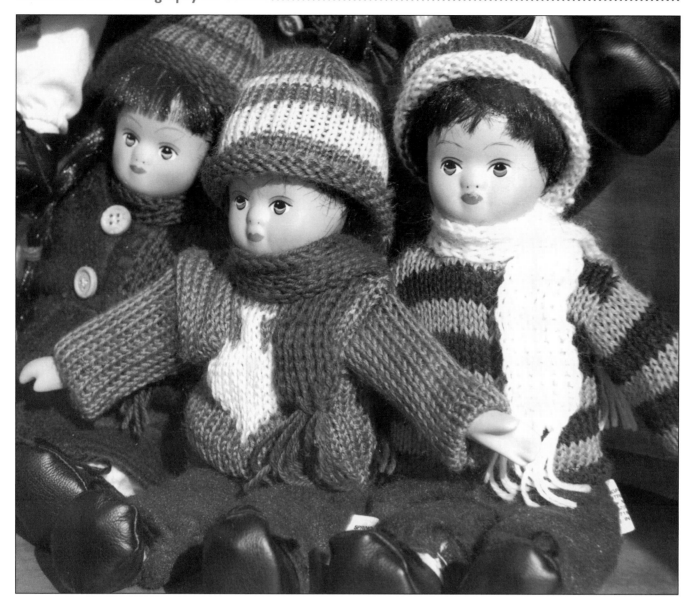

MORE CLOSE-UP PROJECTS

• Create and photograph a psychological self portrait using only small objects.

• Get really close up and photograph something that you would never dream of photographing to discover compositional possibilities. For example, the famous photographer Richard Avadon photographed cigarette butts extremely close up.

CHAPTER **6**

Sorting It All Out

☐ About This Chapter

At this point in the book, you have learned the basics of camera use and photographic composition. You've covered the parts of a camera, how they work together to create a photographic image and some of the accessories that can be used to manipulate those images. This chapter, which marks the end of the first section of the book, provides you with a few exercises to help you practice using the knowledge you've acquired thus far to create well-conceived and well-composed photographs. There is another chapter similar in form and function to this one at the end of the book which will go one step further: it will require you to use all of the contents of this book to not only photograph but also develop and print your work. It is also recommended that you repeat these exercises until you feel comfortable photographing any subject in any setting with whatever accessories you think are appropriate. Once you feel confident shooting with the camera, you can then move on to learning the procedures for developing and printing your work.

☐ People Portraits

Photos of people may be divided into two categories: formal and candid. For our purposes, a formal portrait is a photo of a person posing for a camera in which the lighting and setting are controlled. A candid portrait is a photo of a person in which many if not all the formal portrait controls are missing.

We will first consider the formal portrait because it has many controllable variables. Understanding what the variables are and how to use them will create a successful and unique formal portrait. It will also help us cope with the uncontrollable variables in taking candid portraits.

Below: A basic portrait using a single light placed 45° above and to the right of the subject.

1. Subject. Your model should, first and foremost, be willing to participate in the project. A person's costume and accessories (hat, jewelry, makeup, etc.) are indications of the personality being displayed. You can use props (things held by or close by the subject) that help to convey a particular mood or characteristic of the person. But be careful: a traditional portrait concentrates on the face of the person and not on other visually more interesting objects.

2. Background. Perhaps the simplest background to work with is a neutral one. A wall, textured crumpled sheet or blanket works well to eliminate extraneous details and direct attention to the model. Use any available room or outdoor setting which will not distract from the subject. Keep the model far away enough from the background to prevent unwanted shadows from being cast on it by the lighting.

3. Lighting. Lighting is an art. It is also a very crucial and creative study, one which photographers have been involved with since photography's beginnings. You will find much to learn and experiment with in working with lighting.

For a formal portrait, you will need at least two lights. For black and white portraits, the lights should be at least 100 watts each and moveable. At this stage, professional hot lights or flash units are not necessary. Position one of the lights at a 45 degree angle above and 45 degrees to one side of the model. This is called the key light. Position the other light further away on the other side of the subject to fill in the shadows. This is called the fill light. Try not to cast a shadow from the model onto the background.

4. Camera, lens and tripod. You may hand hold the camera when taking formal portraits, but many photographers prefer the steadiness of an adjustable tripod.

Install the camera on the tripod. It is strongly suggested that you mount the camera in the vertical format. Position the camera close enough to the subject to fill the viewfinder with the model's head alone, or move away until there is enough space included to show to the waist. Always focus on the eyes in a formal portrait. Set the camera at a higher number f-stop to insure a greater depth of field. The lens should not show any distortions on the face or background. Very wide or long telephoto lenses should be avoided because they will distort the face. A 50mm to 135mm lens is acceptable, but the ideal portrait lens is about 100mm.

"Use props to convey a particular mood or characteristic..."

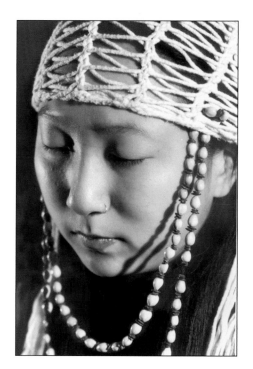

QUICK REFERENCE

Key light: The main source of light in a photograph that defines the texture and volume of the subject.

Fill light: The light source that lightens ("fills in") shadows cast by the key light.

"...make the model feel natural and at ease."

5. Working with Models. Most models will create an artificial pose for the camera. What you are trying to do is gain your model's confidence so that they drop their artificial "mask" and display their real self. It is important for the photographer to make the model feel natural and at ease. Talk to the model, reassuring her that not all of the photos will be printed and that she will have an active part in selecting which negatives get printed for her use. Compliment the model's eyes, face, hair, hands, and jewelry. Make the model feel relaxed. Some photographers are so good at this that you would think that they are personal friends with their clients. Some photographers even try to provoke dramatic expressions on their models' faces. The goal is to capture a genuine expression on a face, not an expressionless mug shot. Shoot as many shots with different poses and props while lighting from different angles.

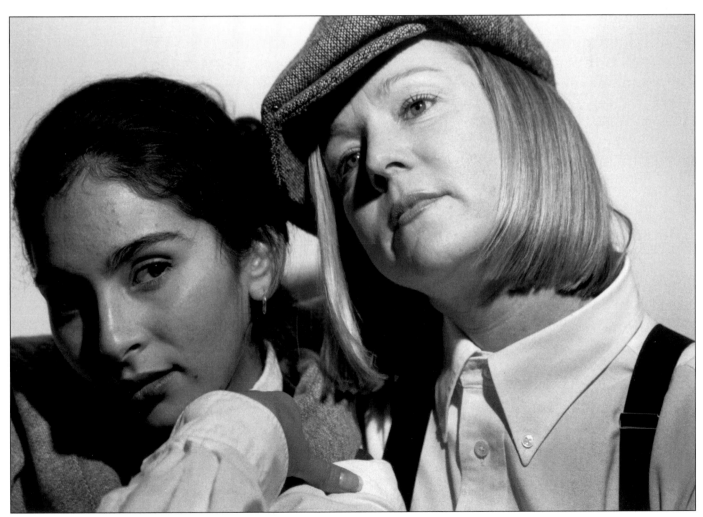

Left: A double portrait that shows how two different complexions (one olive, one fair) are uniquely rendered in black and white.

☐ **Candid Portraits**

In taking candid portraits, few (if any) of the formal portrait controls can be manipulated. In such instances, the photographer must use and capitalize on whatever materials are readily available.

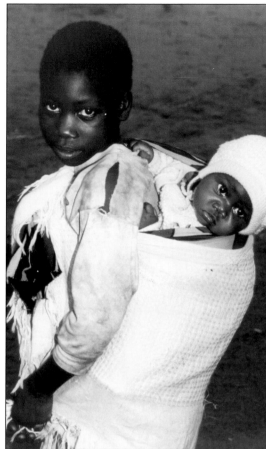

1. **Model and background.** If we cannot change the model's clothing, jewelry, props, background or lighting, we must shoot with what is there. Try to shoot the model with his face in the light. Try talking to him to get his attention if possible. While being aware of the background, look for and position the camera for the best angle to shoot. Using a tri-pod here is not always a possibility.

2. **Lighting.** If your camera has an auto flash, use it but be aware that an on camera flash shoots directly at a subject creating a direction of light that is not natural. The best on-camera flash units have a control setting to minimize the intensity of the flash and thereby create a gentle fill-in flash that gives the illusion of a more diffused light source.

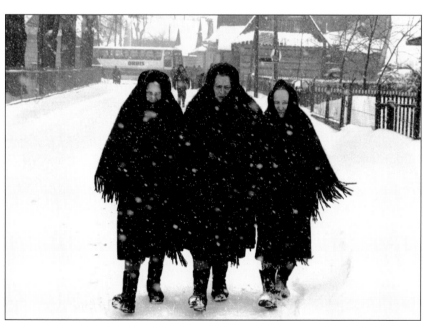

MORE PORTRAIT PROJECTS

• "Create" or catch as many facial expressions as possible.

• Experiment with the placement of lights.

• Using a slide projector, project slides of people, objects, animals, patterns and so forth on your model to create surrealistic portraits.

"Architecture is an artificial landscape..."

☐ Architecture

Architecture is given a special place in this book because it is part of our visual world. It is a constant source of subject material and provides unique opportunities for seeing our environment. Architecture is an artificial landscape and so has many of the same considerations as photographing landscapes. These are:

1. Time, day, season, weather.
2. Background, midground, foreground.
3. Special character of the building(s).

Using these considerations in photographing buildings will provide character in the resulting photos.

When taking architectural photographs, you may encounter certain problems that are related to the lens. Because of the curvature of the lens elements, lenses can have inherent characteristics that affect the straight lines common in architecture.

• **Convergence.** The most simple characteristic of most lenses (including those in our own eyes) is the effect called convergence, an illusion which gives the impression that in a cluster of buildings, their tops appear closer to each other than the bases. The buildings appear to be leaning toward each other. One way to correct this is to photograph the building from a point that is roughly at half the height of the building, assuming you can get up high enough. Another way to compensate for convergence is the use of a very special perspective control lens. A third way is to get the camera on ground level, move back a distance until the entire viewfinder shows the building without distortion, enlarge that image and crop it in the darkroom. Most of the time, the distance required is impossible to achieve. Instead of trying to overcome this effect, you'll do better to accept the effect as being somewhat inevitable and enjoy its creative distortion of the architectural world.

QUICK REFERENCE

Convergence: Phenomenon where lines that are parallel in a subject appear uneven in an image.

Below: An example of convergence.

2. Bowing. Another lens characteristic that may distort straight or curved architectural lines is bowing. This is considered an undesirable effect and is avoided in traditional photography because of its distorted images. The effect of bowing becomes more pronounced as the angle of vision widens. The expanding outward of lines occurs especially in those appearing near the viewfinder's perimeter. The horizon line will bow as well if the lens is pointed up or below the earth's horizon. (An example of bowing, or barreling, can be found on page 61).

3. Pincushioning. Another undesirable lens characteristic in architectural photography is pincushioning, which appears as the opposite of bowing. In pincushioning, the outside lines near the viewfinder appear to bend inward when using a telephoto lens. Unfortunately, there is no easy cure for this effect.

Bowing and pincushioning are not inherent in all lenses. Better quality lenses have fewer occurrences of these effects. The newer computer designed Aspheric lenses claim to have virtually eliminated these problems.

□ **Architecture Exercises**

Shoot any one or a group of buildings displaying its character. To do so follow this list:

1. Shoot early or late in the day for the best angle of light.
2. Shoot the corner of the building to show both sides of it.
3. Look for reflections in the windows. This often provides interesting perspective.
4. Look out for wires, telephone poles, trash, cars. These are usually undesirable.
5. Include people in the photographs to show scale.
6. Look for shadow shapes as part of the composition.
7. Move in close and isolate architectural details as abstractions.

> "Bowing becomes more pronounced as the angle of vision widens..."

QUICK REFERENCE

Bowing: Effect where straight lines in a subject appear as outwardly curving lines in an image.

Pincushioning: Effect similar to bowing, except that straight lines curve inwards towards the edges of an image.

MORE ARCHITECTURE PROJECTS

• Photograph only selected portions of buildings such as all doors, windows or roofs.

• Photo-chronicle the complete construction or demolition of a building.

SECTION TWO
Making Pictures

CHAPTER 7
Darkroom Equipment and Organization

Schools, colleges, local museums or rentable commercial photo labs may have equipped darkrooms. No smoking, eating or drinking is recommended in the darkroom. Proper ventilation of the darkroom is highly recommended. If you prefer to do it alone, here is what you will need:

1. Ventilated light proof room
2. Safelight
3. Photo enlarger
4. Timer
5. Printing easel and photo paper
6. Grain focuser
7. Wet sink with running water
8. Wet sink chemicals, dektol, fix, print washer
9. Wet sink trays, tongs, squeegee
10. Drying area

☐ Darkroom

The room in which you work should be light tight, meaning no light should be able to get in. The room should be ventilated. The room does not need to be painted black. A safelight may illuminate the room.

☐ Safelight

The specific kind of safelight is coordinated with the type of photographic paper that you are using. Recommendations for the safelight are found in the package directions for the photo paper. Do not open a package of photo paper anywhere except under safelight illumination. The placement of the safelight should be about three feet away, depending on its brightness.

"Proper ventilation of the darkroom is highly recommended."

QUICK REFERENCE

Safelight: A red light used during printing to provide general illumination without giving unwanted exposure.

"The wet sink is the command center for print development."

□ The Wet Sink

The wet sink is the command center for print development. An essential is a sink with a drain and running water. It should be big enough to hold all three developing trays and a print washer. All the trays in the sink should be big enough to hold the size print that you are working on. A tray to fit an 8 x 10 print is a good place to begin. Make certain that the trays are larger than the 8 x 10 print. In all three trays, rubber-tipped bamboo tongs are recommended instead of the metal type.

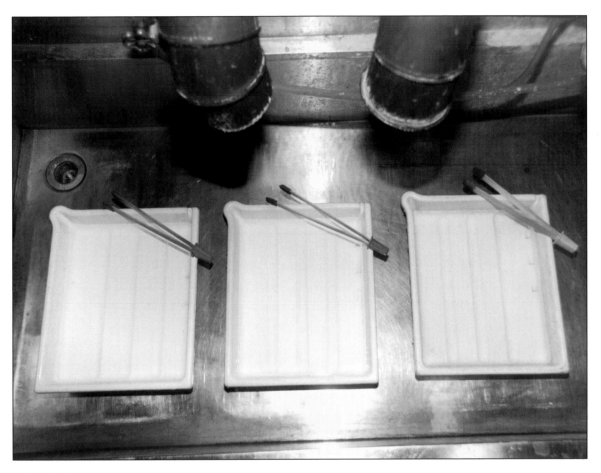

Above: Photo developing trays in the wet sink.

□ Developer

The sink holds a tray of developer, the usual kind being Kodak Dektol 2:1, or a working solution of two parts water to one part Dektol at room temperature. The tray should also have a pair of tongs.

□ Stop

To the right of the developer tray should be a tray of stop (which neutralizes the developer and "stops" the chemical reaction). This is room temperature water to which is added a specific amount of Kodak stop concentrate. Read the label for the correct amount. It should have a pair of its own tongs.

☐ **Fix**

The third tray to the right is the tray of fix, sometimes called fixer or hypo. It is the same fix that you will have used in the negative developing process. It is a stock solution. This tray is also at room temperature and has a pair of tongs.

☐ **Print Washer**

Next to the tray of fix is the print washer, which is usually connected to the sink faucet. It runs slowly and continuously, refilling the used, spilled off water. Other simpler washers are also available at your local photo equipment store. To save water and time in print washing, just as in film developing, you may use another bath of hypo clearing agent.

Below left, top: An adjustable two-bladed printing easel.
Below left, bottom: A grain focuser.
Below right: An enlarger station with enlarger, timer, printing easel and grain focuser.

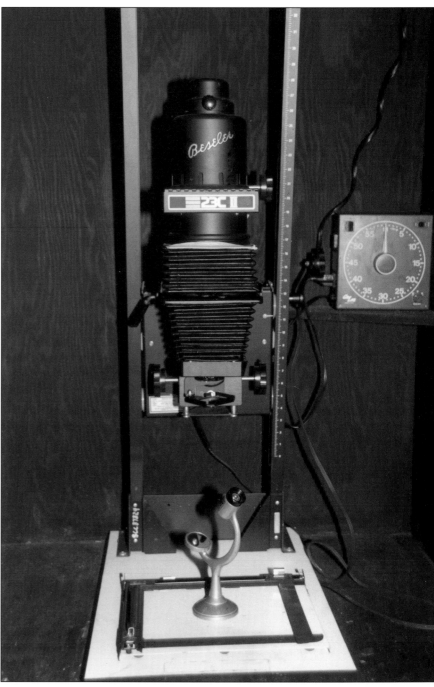

"...have a designated area for the necessary drying of the print."

☐ Drying Area

Most photo labs have a designated area for the necessary drying of the print. You will be using a resin coated photo paper that simply needs to be squeegeed on both sides and then allowed to air dry. Some better equipped labs have a print drying cabinet that has circulating warm air to speed up the print drying time.

☐ The Enlarging Station

The enlarging station contains the enlarger, a timer, a printing easel, a grain focuser and space for photo paper and negatives. The timer is connected to the enlarger and turns the exposing light on and off according to how it is set

The printing easel sits at the base of the enlarger. It holds the photo paper while it is being exposed by the enlarger. It may be the single size version or the multi sided version, which allows you to create any size photo that you desire. The grain focuser is used under the enlarger light to actually focus on the grains in the negative. This insures exact enlarger focusing.

CHAPTER 8
Film Development and Procedures

☐ Developing the Negatives

The process of film development calls for a mechanical loading procedure and a controlled series of wet-chemical baths. A list of supplies includes:

1. Cassette of exposed 35mm b&w film
2. Round ended bottle or can opener
3. Small scissors
4. Film developing tank, top and reel
5. Thermometer to measure temperatures of chemicals
6. Graduate cylinder to accurately measure liquid chemicals
7. Pre-mixed film developer, Kodak D-76
8. Pre-mixed film fixer, Kodak Fixer
9. Pre-mixed Kodak wetting agent
10. Film clips to hold wet film while drying
11. Plastic negative holder sheets to hold dry negatives.

The initial step in film loading must be accomplished in complete darkness. A lightproof changing bag should be used in daylight. A changing bag is a double lined lightproof cloth container with two arm holes and a double zippered opening. Film loading may be done in a changing bag or a dark room of any kind, so long as there are no light leaks. In either setting, place the following where you may identify them in the dark:

- film cassette
- round end bottle or can opener
- small scissors
- developing tank, top, film reel

Study the film reels in daylight to determine where the film is inserted.

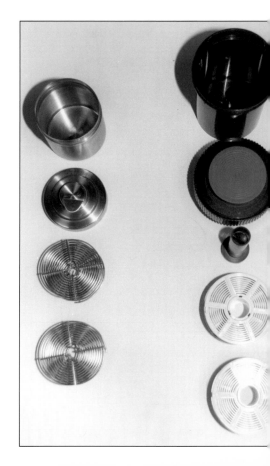

Below: Developing tanks, tops and reels. The group on the left is the metal type, and the group on the right is the plastic variety.

☐ Loading Film onto Developing Tank Reel

The first step in developing your film is to correctly load your film into the developing tank. Below are the steps for accomplishing this task and illustrations to help you understand each step visually as well as textually.

1. Popping open cassette. Use the bottle opener to gently pry up the flat end of the film cassette all around its perimeter.

WARNING: These steps must be performed in complete darkness (either in a changing bag or totally dark room). Any exposure to light (even a safelight) will ruin undeveloped film!

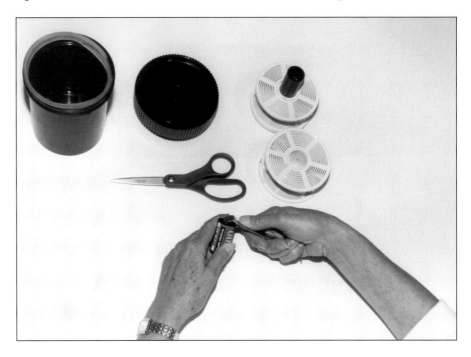

"...cut off the leader where the film widens to its regular size."

2. Cutting leader off. Remove the roll of film from the cassette. With the scissors cut off the leader where the film widens to its regular size. Cut the film at a right angle, making two right angle corners.

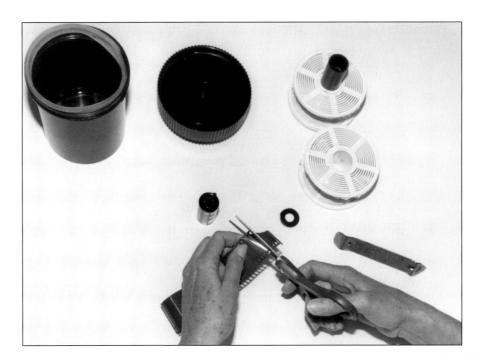

3. Cutting film end and threading end onto reel.
Grasp the cut film, glossy side up, and insert in the indicated film reel slots. Gently pull it forward a few inches.

QUICK REFERENCE

The glossy side is on the out-side of the curve of the film. You can also evaluate this by feeling which side of the film is more smooth and glossy.

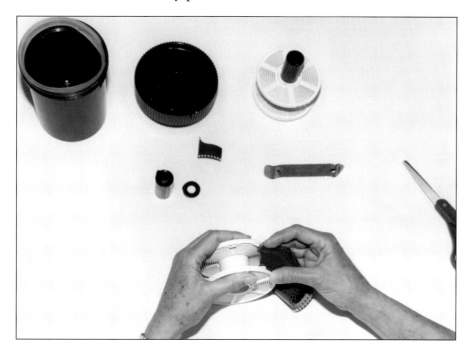

4. Twisting reel to advance film.
Hold the film reel in the left hand fingers. Place the right thumb on the glossy film surface while grasping the reel with the remaining fingers. Gently push the film forward with the right hand while moving the left hand toward your body. This technique will load the roll on the reel. A small spool will be attached to the film. Cut it off with the scissors.

"This technique will load the roll on the reel."

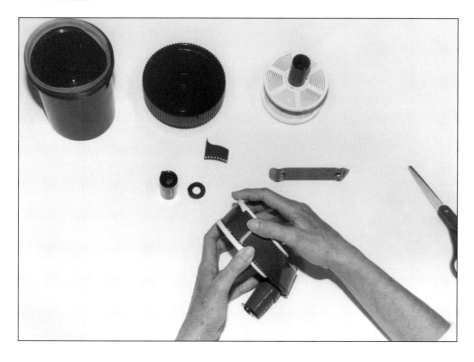

5. Placing rolled film in tank and placing cap on top. If the tank has a spindle, insert it in the film spool. If not, place the loaded reel into the film tank. Place the light tight top on the tank and remove it from the changing bag. Proceed to the wet sink containing all the pre-mixed chemicals.

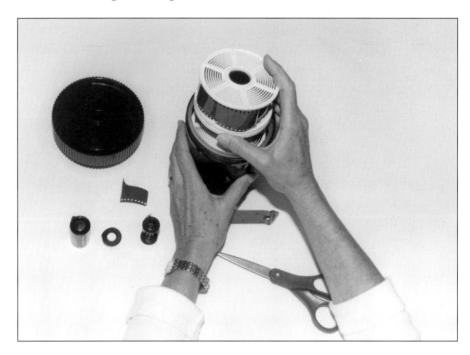

□ Developing the Film: Wet Chemical Procedure

Prepare the chemicals for film developing according to the package directions. This initial mixing produces a stock solution which must be further diluted with water to use. The standard film developer is Kodak D-76. Dilute the D-76 Stock solution 1:1 or one part water at 68 degrees to one part Stock D-76 at 68 degrees. This is called the working solution. The chart below will provide you with a choice of working solution temperatures.

"...work over a sink to prevent wet chemicals from spilling."

D-76 Working Solution for 400 ISO Tri-X Film	
Temperature	Time(minutes)
65	11
68	10
70	9.5
72	9
75	8

Perform all the following steps by removing only the cap top – not the entire lid of the developing tank. DO NOT OPEN THE FILM DEVELOPING TANK UNTIL THE FINAL WASH TO PREVENT FILM EXPOSURE. It is also a good idea to work over a sink to prevent wet chemicals from spilling. If some chemicals do wet clothing, fabrics or especially the eyes, flush with water immediately.

1. Film developer.
- **Amount.** Mix working solution. Measure out the ounces needed of D76 according to the amount required (usually stated on the bottom of the tank or in the instruction booklet.)
- **Temperature.** With the thermometer, measure the temperature of the working solution. Consult the chart for the total amount of developing time. Pour in the developer as quickly as the tank will allow and then gently knock the tank on the palm of your other hand two or three times. This action dislodges any air bells or air bubbles caught on the film due to static electricity.

2. Agitate. Immediately agitate the tank four times, inverting the tank upside down and back once every second. Begin timing the developer. The tank must be agitated four times every thirty seconds (five times for Kodak T-Max films.) Agitation is necessary to keep the developer moving and keep it from over or under developing the film.

3. Empty tank. When completed, pour out and discard the D76 working solution into a container to be discarded as toxic waste. It is good for one time use only.

4. Stop bath. Next, fill the unopened developing tank with ordinary tap water at 68 degrees until it overflows. This is called the stop bath. Agitate the tank constantly for one minute and pour the water down the drain. This step stops the developer.

5. Fix. The next step is to fill the tank with fix (or fixer), which is a stock solution that you have pre-mixed. Agitate continuously for the first thirty seconds and for every thirty seconds after that, 2-4 minutes for liquid fix or 5-10 minutes for powdered fix. It should be room temperature (about 68 degrees). This step fixes the exposed particles of silver halide on the film surface. When completed, pour the fix back into a container marked USED FIX for later use.

6. Wash. Wash the film in the developing container using running tap water at the recommended 68 degrees or room temperature for five minutes. Kodak recommends filling the tank and emptying it ten times for a quicker wash. Another quick wash which also saves water is the use of fix or hypo eliminators (there are many commercial brands). Follow label directions. This step washes away all the remaining silver halide and remaining chemicals on the film.

"Agitation is necessary to keep the developer moving..."

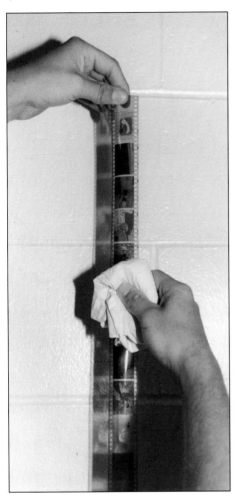

Above: Wiping developed film.

7. Dry. Remember that the exposed and now developed and fixed chemicals are in a wet gelatin base on the film. Handle wet film only on the edges – avoid touching wet film surfaces. Remove the film loaded spool from the tank and dip the entire reel in a mixed solution of wetting agent (like Photo Flo) for **30** seconds with gentle agitation. Remove film from the spool, attach film clips to both ends and let dry in as dust free an environment as you can find. Some photographers use a small lint free sponge dipped in Photo Flo to wipe the glossy or non emulsion side of the film length. Let hang as long as it takes for them to dry.

8. Store. When dry, remove film clips. Handle the film only by its edges and cut it into strips that will fit into a clear plastic holding sheet (usually five or six frames to a row). Hold the sheet up to the light to inspect your negatives.

CHAPTER 9

Enlarger and Exposure Tips

☐ Using the Enlarger and Determining Exposure

The enlarger is a piece of equipment that exposes a negative with a controlled amount of light. A negative is placed in the film holder in the enlarger. The head of the enlarger is moved higher or lower, changing the size of the negative image projected down on the printing easel. The enlarger head contains condenser pieces of glass and a lens to control the size of the projected image as well. The image must be focused by turning the knob on the enlarger and aiming the grain focuser upwards at the projected image. The enlarger lens is in the head of the enlarger. Just as with a camera, the enlarging lens has apertures (f-stops) that must be set.

The following steps will take you through setting the enlarger and other equipment and making a test strip. A test strip displays a number of sequentially timed exposures to determine the correct exposure time.

1. **Placing negative in film holder.** In the darkroom with only the safelight on, place the selected negative in the film holder, shiny side up, dull or emulsion side down. Turn on the timer and the enlarger light.

2. **Select image size.** Crank the enlarger head up or down to select the size of the projected image on the easel.

3. **Focusing the image.** Focus the image with the aid of the grain focuser.

4. **Determining the aperture.** Determine the aperture (f-stop setting). An excellent place to begin this critical step is to look at the projected image and turn down (make dimmer) the apertures, dimming it until the details in the projected image begin to disappear for you. That is where you begin your f-stop placement.

> "...the enlarging head has apertures (f-stops) that must be set."

☐ Test Strip

You can determine exposure time by making a test strip. The test strip is necessary for every photo because every photo has a number of different light conditions that require a different exposure f-stop and test. Once you have your image enlarged and in focus, turn off the enlarger light. Using only the safe light, place a 1" by 8" or 10" strip piece of photo paper, glossy side up, in the printing easel on the most important part of the composition. You will be using an opaque piece of paper that is moved two inches every two seconds across the length of the photo paper strip.

Above: A test strip created at three second intervals.

Below: A projection print scale.

In lieu of a test strip, a very handy tool for determining exposure time is called a projection print scale. It is a piece of clear plastic on which are pie-shaped wedges of different grays. Each wedge shape has a number corresponding to its final enlarger time. It is placed on a test piece of photo paper and exposed at a pre-determined f-stop for one minute. It is then developed using the wet sink method described on pages 96-8.

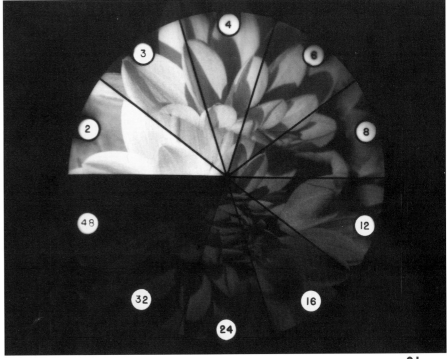

☐ Burning

Occasionally you will find an extremely bright area in a print which appears to have no details in it, even when printing filters and a positive exposure compensation are used. A way to produce details in a very bright area when printing a photograph is to use the technique of burning, sometimes called burning in.

After printing a photograph and discovering that a section needs to be burned in, take a piece of opaque paper in which a small dime size hole has been cut. This is your burning tool. Expose another print in the same manner as the previous one but without wet sink development. With the enlarger off, position the burning tool hole where the bright area is on the print. Now turn on the enlarger and give only the white area more time. Slowly move the burning tool around, making circles to avoid making sharp edges on the print. When burning, a good rule of thumb is to double the original amount of exposure time. Becoming proficient at burning may take a bit of practice, but you will find that this is a technique that you will want to use on many different photos.

The pictures on the next page are good examples of how burning can be used to improve an image. This process could be especially useful when attempting the white on white exercises in Chapter Three (pages 37-42.) To practice burning, you may want to return to those exercises and use this process to improve the quality of your compositions.

"Becoming proficient at burning may take a bit of practice..."

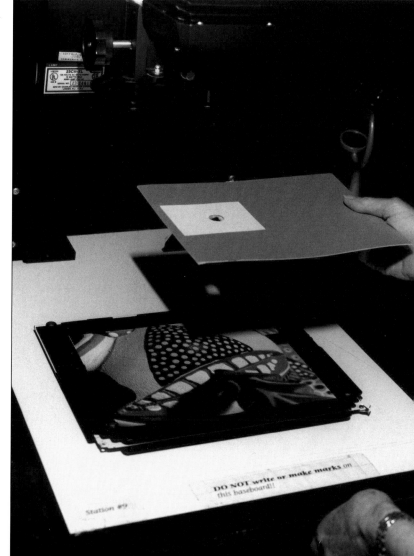

Right: Technique for burning in an overexposed part of an image.

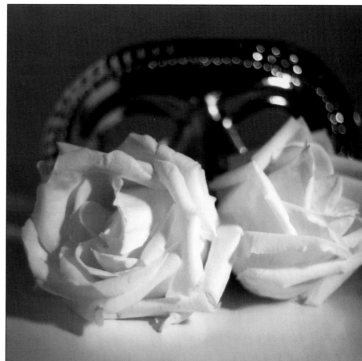

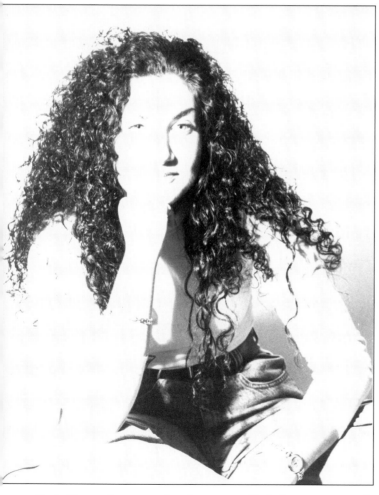

Left: Two photographs that are slightly overexposed. Note the loss of detail in the center of the roses and on the main light side of the woman.

Right: The same two photos altered by burning. This process allows you to change only the portions that need adjustment instead of reshooting these images.

☐ Dodging

If you discover areas of your print that are pure black and lacking detail, you may want to use another valuable printing technique called dodging. This is a printing technique that prevents light from overexposing or darkening a specific area of the print. To dodge an area, you need to purchase or make a dodging tool, which is a thin, stiff piece of wire to the end of which is attached a custom sized piece of opaque paper. To use it, place the tool so that the end with the paper attached to it covers the area which is too dark and slowly move it over this area to prevent making marks on properly exposed areas during the initial exposure time. Just how long the dodging should take is a matter of experimentation, since all negatives are different.

The two photographs on the following page are a good example of an image before and after dodging. This process could be especially useful when attempting the black on black exercises in Chapter Three (pages 43-45). To practice dodging, you may want to return to those exercises and use this process to improve the quality of your compositions.

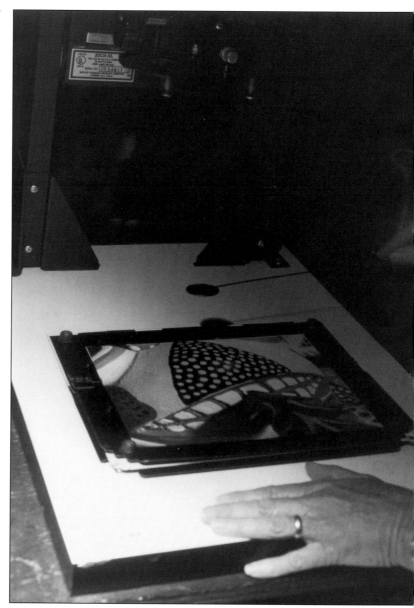

Right: Technique for dodging an under-exposed part of an image.

At top, a photograph that needs to be dodged. With the sun at this angle, the shadows obscure the features on the right side of the girls' faces. It would be a shame to lose such an adorable image and nearly impossible to recreate it. However, dodging techniques can salvage such a picture, as is demonstrated by the bottom image. By selectively dodging the darkened areas, the girls' faces are lightened and are now completely visible. Using this technique can save you the time and frustration of trying to recapture moments that you may simply not be able to photograph again.

CHAPTER 10

Print Developing

☐ Developing Prints

At this point, you have created a test strip that will help you decide if you have used the correct exposure setting. With the safelight on, take the exposed test strip of paper or large sheet of exposed photo paper to the wet sink. The procedure for print development is as follows:

1. Developer. Without pausing, slide the piece of exposed paper into the developer tray filled with a working solution of Dektol. Immediately take the tongs, grasp a corner of the paper and constantly agitate it, changing the section where the tongs hold onto the paper. Continue agitating until the darkest areas are visible and seem almost too dark. This could take anywhere from 30 seconds to a minute or more. The reason for this is because in the darkroom we look for lights, whereas in the daylight we look for darks. When you have decided on the darkest blacks, lift the paper out of the developer, let drain a few seconds and without touching the next bath, drop it into the stop tray. Replace the developer tongs to their tray. **NOTE:** Placing tongs in the wrong trays may result in the contamination of development baths.

2. Stop. Using the stop tongs, hold onto the print and agitate for about 30 seconds. Pick the paper up out of the stop. Let it drain for a few seconds and drop it into the fix. Replace the stop tongs.

3. Fix. Pick up the print with the fix tongs and agitate it for the first 15 to 30 seconds and after that occasionally for five minutes if you are using RC paper. Replace the fix tongs.

"...in the darkroom, we look for lights..."

4. Squeegee. With your hands, pick up the washed print, take it to a clean flat surface and lightly squeegee the front and back sides of the print. Allow it to dry. When dry, handle finished prints only by their edges, being careful not to touch their surfaces.

☐ **Evaluation**

Study the test strip that you have developed. There should be regular sections of progressively grayer or darker sections all the way to the end of the strip. Select the section that shows the best contrast.

Go back to the enlarger station. Do not move the enlarger position or lens f-stop. Place a full sheet of paper in the printing easel. At this point, you may turn or reposition the printing easel. You may also choose to make the paper size smaller (also known as cropping.) You may reset the blades on a flexible printing easel to make the image have more of a background. In short, you may exercise your own creative ideas about the picture's composition.

To make a print, set the timer for the determined amount of time and expose the paper. Follow the exact developing procedure stated previously to make a finished print.

☐ **Contact Sheet**

In most cases, not every negative will be printed. To help us make our decision about which negatives to select for print-making, there is a slight variation on the printing process that produces a complete sheet of actual photographs in the same size as the negatives. This device is called a contact sheet (sometimes referred to a proof sheet). Use the following steps to create a contact sheet:

1. Replace the negative holder in its normal position in the enlarger, but do not place a negative in it.

2. Turn on the enlarger and move it so its light projects slightly larger than 8x10". Place an 8x10" piece of ordinary paper there. Do not use a printing easel.

3. Take plastic sheet containing the negatives and place it on the ordinary paper.

4. Set the f-stop on the enlarger lens at f-11 and set the timer for 10 seconds. This is an acceptable initial setting that can be modified depending on the density (darkness/clearness of the negatives).

"In most cases, not every negative will be printed."

5. Turn off the enlarger. Slip an 8x10" piece of photo paper, shiny side up, underneath the plastic sheet containing the negatives. Cover with a clear sheet of glass or Plexiglas to weigh it down and make contact with the paper.

6. Expose for ten seconds at f-stop 11. Turn off enlarger.

7. Develop the paper in the wet sink.

8. Evaluate the print. Deciding to make another lighter or darker print of the same negative requires consulting the test strip timings. Changing the size of the enlargement or changing the enlarger aperture will necessitate another test strip. To make the enlarger exposure darker, extend the exposure time a few more seconds, or open up the aperture to a smaller numbered f-stop. Rarely will an exposure need both at the same time. To make the enlarger exposure lighter, give the exposure less time or close down the aperture to a larger numbered f-stop.

9. Squeegee and dry the print.

"Cover with a clear sheet of Plexiglas to weigh it down..."

Below: A contact sheet.

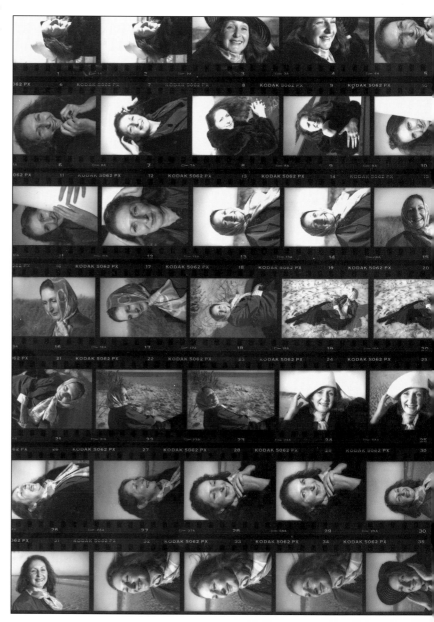

CHAPTER 11

Printing Papers & Printing Filters

☐ Printing Papers

Printing paper is a single, medium or double weight or thickness paper which is coated on one side with a light sensitive material on which exposures are made. The back side of the paper is blank and has no chemicals.

Photographic printing paper is available as a fiber based paper or as a resin coated paper. It comes in a number of surface textures (including glossy, matte, and pearl) and in such popular sizes as 5x7", 8x10" or larger. RC (or resin coated) papers are coated with a resin surface that allows for quicker developing and drying times. It is recommended that the beginning student first use RC papers. Fiber based papers hold more water and take longer to dry, but some photographers claim that they display a finer image.

Photo paper is also available in a range of contrasts. Normal contrast is considered #2 or #3, but contrast grades are available up to #9. Rather than keep a number of packages of various contrast grades on hand, it is recommended that you purchase VC or variable contrast paper. VC paper produces any of the contrast ranges when used in conjunction with VC printing filters.

☐ Printing Filters

Printing filters are individual pieces of different colored material that are placed in the enlarger to create a variety of effects. VC filters are numbered one to five and are placed under the lens during exposure. Number one removes the least amount of gray, while a number five removes the most amount of gray. They effectively reduce the amount of gray in the exposure and thus produce more contrast in the finished print.

"Fiber based papers hold more water and take longer to dry.."

CHAPTER 12

Putting It All Together

☐ Putting It All Together

Putting together all the information that you have learned thus far about picture-taking and picture-making may seem like an arduous task, but practice and experience will help. The processes of using the camera and of film and print developing work together to help you create a photograph that will capture the essence of your visualization. By recognizing and using the virtually infinite possibilities made available by every scene, you can utilize camera and darkroom techniques to make truly stunning images. To provide you with just one example of this potential, the next section demonstrates the process that went into creating a technically and compositionally sound photograph. They offer you a unique glimpse into the development of the best possible representation of a scene by taking you through each phase of the process and explaining the adjustments that have been made.

Photo #1: Identifying a Subject

The first step in creating an image is choosing a suitable scene to photograph. This decision should be based on your personal preferences, if the picture is for your enjoyment alone. However, if your purpose in taking the picture involves other people besides yourself, then the subject's significance to your audience should also be taken into consideration. A fine art image, whether it be taken by an experienced professional or well-informed amateur, often requires several shots to fully capture the essence of both your artistic vision and the best qualities of the subject itself.

This image was taken on a dark cloudy day with a 50mm standard focal length lens. As it stands, the picture should raise several questions in your mind. Does the lens have an adequate angle of vision to capture and compose the scene? The dark foreground is out of focus due to the dark weather conditions, which also steal valuable f-stops. Does the vertical format enhance the composition or limit it? Realistically, no amount of printing filters or dodging will salvage this negative or the resulting print. Since this is only a first attempt, think through your options and return when the weather conditions are more conducive to a successful shot.

Photo #2: Same Scene, Different Day

On this day, the weather had improved considerably. This picture was taken at midday with a 35mm lens to provide a wider angle of view and improve the composition. The brightness of this day permitted the use of an f-16 aperture, insuring a greater depth of field. A horizontal format was used instead of a vertical one; this afforded a better display of the winding wetlands stream, which is the main focal point of the composition. Making these adjustments greatly improved the photo in comparison with the results of the first attempt. Still, there were areas that obviously needed further modification if the true potential of the shot was to be captured.

It is not an unsuccessfully composed image, but there were a few areas that could be strengthened. The image had an overall gray contrast range, making the blacks and whites appear muddy. Given this, it became apparent that the quality of light was what needed to be improved. More specifically, the direction of the light did not allow for optimal illumination of the scene. Again, the best course of action was to rethink the available options and return at a better time of day to capitalize on the available light.

Photo #3: Same Day, Different Lens

This photo was shot after returning to the scene later in the day, which offered better light with which to work. Notice how the shadows that were present in the previous images have lightened considerably. Instead of the 35mm lens, a 120mm telephoto lens was attached to the camera to narrow the field of view and bring the scene a bit closer. As a result of these adjustments, the scene is brighter and the composition fills the entire frame. This is definitely an improvement, but by the same token it is not without its problematic areas.

While the composition is indeed tighter, it is so close that it runs off the sides of the picture and unnecessarily divides the composition. In addition, the depth of field has been altered in such a way that both the foreground and the background have become blurred. Without overall sharpness, blurred subjects (such as the visible portion of the bush in the foreground) become distractions that detract from the appeal of the scene. Although the image has not yet reached its full potential, eliminating certain options has brought it closer to the ideal than the original shot.

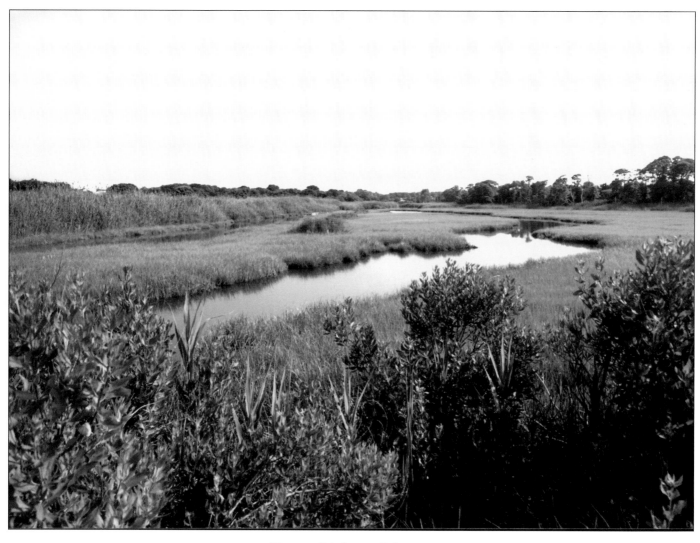

Photo #4: Late Afternoon

This shot was taken only a short time after the previous one, but the lighting this time was exactly what it needed to be for the best photo opportunity. The sun is at a 45° angle to the scene, creating the most desirable shadow formation so far. Since the last shot was a bit too tight with the 120mm telephoto lens, a 28mm was used so that the stream extended most of the way towards the edges of the picture without overlapping them. Com-bined with an aperture setting of f-16 focused in the center of the composition, this image has an excellent depth of field and well-balanced sharpness throughout. To darken some the greens, a red filter was attached to the lens.

At this stage, the conditions for shooting this type of scene are very close to optimal, but the issue of balance needs to be addressed. The very dark shadow at the bottom right of the photo is a distraction that must be dealt with. As it stands, this dark area creates an uneven bottom frame that ends up drawing the eye away from the main focal point of the photo – the stream winding away into the distance.

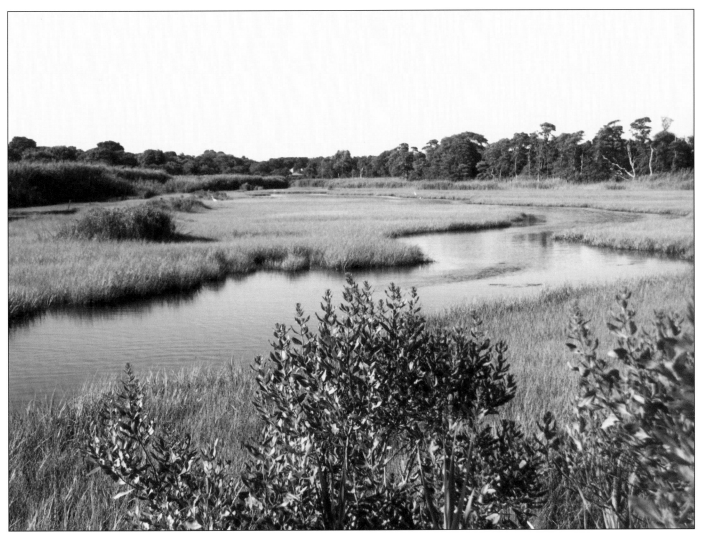

Photo #5: Same Time, Different Lens

This shot was taken at the same time and under the same conditions as the last one, but a different lens was used in order to eliminate some of the distracting flora that previously stole attention. A 50mm lens was utilized to display the scene from approximately the same angle of vision that might be seen by the human eye. This has successfully reduced the amount of plant life that frames the scene without eliminating it completely.

Unfortunately, however, what is left is still a disturbance to the scene. The bush in the foreground extends halfway up the picture and manages to remain a distraction. In addition, the change in the angle of vision has now made the stream touch both sides of the frame, essentially bisecting the composition and forcing the eye to constantly shift between the two halves. Instead of being the main focus of the image, the stream has been reduced to a line that the viewer's eye must jump across while searching for a subject to rest upon. This is an undesirable trait in any photograph, so once again the choice of equipment combinations must be reevaluated.

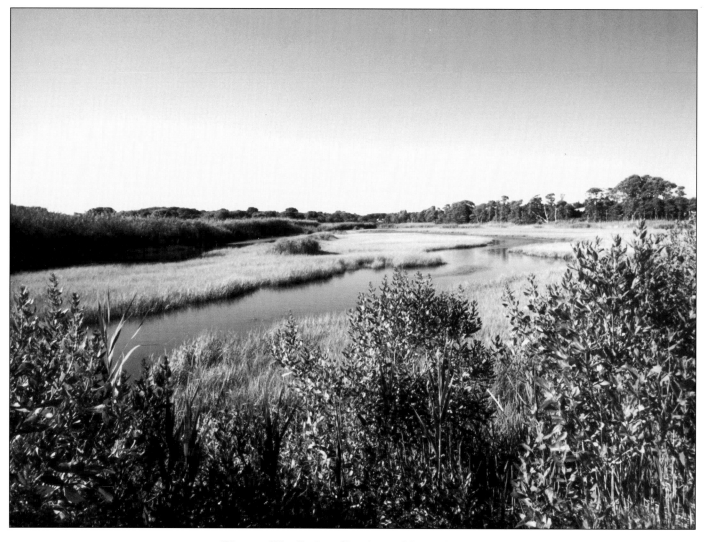

Photo #6: Going Back to Move Forward

Sometimes the sole purpose of making certain adjustments is to realize that you probably shouldn't have changed them in the first place. Although trying to assume an angle of vision similar to that of the human eye was a sound idea, in this case it did more harm than good. Acknowledging this, it was decided that the best plan of action was to go back to the 28mm wide angle lens. A polarizing filter was also attached to the camera to reduce the amount of glare off the water and bounce highlights from the scene. Later in the darkroom, the upper portion of the sky was burned in to provide a darker tone.

At this point, one might think that the photo has been altered enough that it meets the criteria for an acceptable image. It is by far the best of the five before it, and certainly it could stand on its own. But as a photographer's level of experience increases, it is the attention to the finer details that becomes crucial to continued artistic growth. And in this case, there seemed to be room for improvement. The bushes are too numerous and still steal attention away from the stream. They must somehow be controlled if the stream is to remain the dominant focus of the scene.

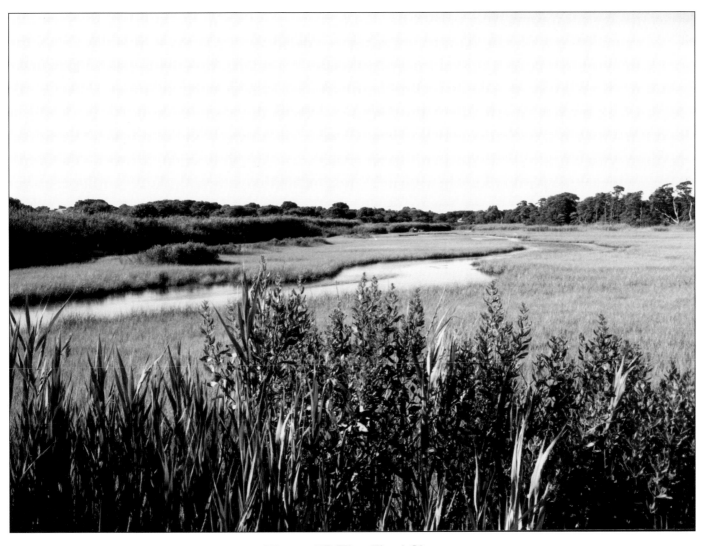

Photo #7: The Final Shot

Instead of taking a hedgeclipper to the bushes to "control" them, an easier adjustment was made: this image was taken two feet to the left of the previous shot. A minor adjustment to be sure, but it had a major effect on the final product. The bushes in the foreground are considerably less active and hence less distracting than in the last shot. Instead of stealing attention, they now cushion the scene and are a less intrusive bottom frame. The eye no longer rests on them; in fact, they are briefly pulled over the bushes, ushered into the main part of the scene and finally drawn up the stream and into the distance. Here too, the stream enters the frame from the left side and winds placidly across the scene and away from the viewer.

There is very little difference between this image and the previous one, and both are acceptable compositions of the same scene. In the end, choosing which one is "better" is a matter of personal preference. That is the beauty of photography and any form of art in general: the individual has the final word in deciding what best meets his or her own artistic criteria. If there is anything missing from this shot, it is some centered clouds to complete the composition. But that can be left for another day...

CHAPTER 13
Conclusion

The magic of black & white photography is now one of the traditional, classic fine arts. In the same way that basic drawing was humanity's first method of rendering its world and each individual's understanding of it for centuries, photography has now become another vital medium for those expressions.

With photography, we can record our world with dazzling accuracy or with subjective vision. The choice is ours. Utilizing the camera's controls extends our vision and permits us to share our realities with the rest of the world.

Today, the volume and speed of communications increases at a rate proportional to the rate at which the globe seems to be shrinking. As photographic artists, we have the responsibility to communicate our human vision at a higher level of consciousness. Selecting what to photograph is the primary level upon which we communicate our vision to the world. Selecting how to photograph those images permanently imprints them with our unique vision, as well as burning them into the history and memory of our world.

Today the computer has become a tool of daily life, both at home and in the workplace. With all the marvelous feats of photographic manipulation and handling possible with a computer, it is essential to remember that this is just another tool. We alone take and make the photograph; the computer can only affect the changes that we choose to make to that image. Without the photographic image, no manipulation is possible. Photography is an essential human art form, and we must never lose sight of the fact that we are its creators.

With time and practice, your photographic skills will bloom. Just as in riding a bicycle or driving a car, you begin by learning how all the controls work – then, with familiarity, you find that using them becomes second nature. It is then that we can

"Photography is an essential human art form..."

108

"Your skills will become intuitive and responsive to your demands."

branch out, attempting photographically (to stay with the analogies) the equivalent of riding wooded trails or driving across the country.

Your skills will become intuitive and responsive to your demands. Then you will be able to photograph from within, turning your visions into personal statements, into Art. As you get beyond the concerns of f-stops and shutter speeds, you will get deeply involved with your subject matter – and it is this involvement which permits your heart and personal creativity to come through for all the world to share.

SECTION THREE
Appendices

APPENDIX A

Choosing the Right Equipment

In selecting 35mm photo equipment, it is important to determine your requirements for photographing. Subjects that you select and how they are to be photographed will in large measure suggest the variety of camera equipment that you will need. For example, if you are to photograph only landscapes or snapshots, a good quality rangefinder or point & shoot camera will be sufficient. But if you require the versatility of different angles of lenses, numerous shutter speeds and electronic motors, a good SLR will serve your needs.

Investigate camera manufacturers' specific models to discover what controls and features each model has. Brand name companies such as Canon, Minolta, Nikon and Pentax have excellent quality products with a variety of models in all price ranges. The versatility of each model will determine its price. The sturdier the construction and wider variety of features, the more expensive the camera will be.

Go to a reliable and honest photo shop and ask to see the make and model that you have selected. Ask the salesman if the model can use additional equipment such as lenses or a flash unit. Tell the salesman what your camera needs are and ask to see models in the low, mid and higher price ranges. Hold the camera. Determine if the ergonomics are suitable for your hands. Does it feel light, heavy, awkward or just right for you? Are its shutter speed, f-stops, advance levers or other controls comfortably placed? Is the camera in good condition, new and unblemished? Does the camera have a manufacturer's or photo store warranty? Does the store perform camera repairs? Does the store carry additional lenses other than your camera brand that will be compatible with your camera, filters, tripods, etc.? Yes, it does pay to do comparative shopping for photo equipment. Be careful about buying used camera gear. If possible,

"The versatility of each model will determine its price."

111

shoot a roll with the used camera, process it and check the results. Also, ask for permission to take the used camera for a check up at a camera repair shop. Big savings may be realized in purchasing used camera equipment, but unfortunately this is a somewhat risky procedure, similar to buying a used car. Make sure that you know what you are getting before you invest your money.

"Make sure that you know what you are getting before you invest your money."

APPENDIX B
Caring for Your Photo Equipment

You will discover that purchasing camera equipment is expensive. As with any valuable and precise instrument, it should be maintained properly. Use a neck strap to secure your camera while it is with you. You'd be surprised at how many costly repairs are due to a dropped camera! Keep your camera gear in a secure and cool place. An automobile will bake your equipment in the warm months and freeze it in the cold months, which is obviously something to be avoided.

Keep your camera gear clean. The new micro fiber cloths are excellent for keeping lenses and camera bodies free of dust and grime on the outside. On the inside, do not touch the camera back's pressure plate. It is precisely placed and pressured for flat film contact. Use compressed air or a soft brush to remove dust or foreign particles from inside the camera body – both in back and in front where the lens mount is located. Never touch the SLR's mirror. It is specifically balanced and connected to the shutter mechanism, and this precise positioning is crucial to the camera. In placing your camera on a flat surface, many professionals try to place it so that the lens is pointing up, thus relieving pressure on the lens mount of the camera and lens itself.

If your camera is used for extended periods of time, it is wise to have it professionally cleaned and lubricated on a regular basis, just as you would with a fine automobile. Even the most successful photographers, regardless of the size of their equipment budget, know that proper vigilance in maintaining clean camera equipment will greatly increase its longevity.

"...clean camera equipment will greatly increase its longevity."

APPENDIX C
Troubleshooting

☐ Locating the Problem Area

In order to determine a way to fix any given problem, you must first locate the area where the problem originates. For our purposes, this will be one of three areas: the camera itself; the film/negative, or the print. Once you have done this, you can then refer to the list below to find your specific problem, learn of its probable cause and try the suggested remedy.

For many of the problems, there are "cures" that you can try to fix the problem; however, some problems require the abilities of certified camera repair specialists and should not be attempted by yourself. As you become more experienced in photographic techniques and camera maintenance, you will gradually learn ways to prevent some of these common problems before they occur. And if you find yourself becoming increasingly interested in the mechanical aspect of photography, there are a number of guides that can teach you how to undertake more complicated repairs without the assistance of a professional camera technician.

☐ Camera

Problem: Specks of dust seen in viewfinder.
Cause: Dust/debris located in the camera's viewfinder, prism or mirror.
Cure: Use compressed air to blow away dust. Use soft brush to wipe away debris.

Problem: Edges dark in print, called vignetting.
Cause: Filter or lens shade is too small for the focal length of the lens.
Cure: Use larger size filters or lens shades or crop out edges while exposing the print.

Problem: All exposures too light or too dark.
Cause: Camera light meter or batteries failed. Camera aperture jammed.
Cure: Replace batteries. Check camera light meter for logical readouts. Professional camera repair.

Problem: Film advance lever jammed.
Cause: Forced or broken film advance lever.
Cure: Try depressing the shutter button. Try pressing the film release button and rerolling the film into the cassette to try to save the film. Professional camera repair.

Problem: Flare; Bright light appearing in the viewfinder and print.
Cause: Light source(s) shining directly into the lens.
Cure: Re-angle composition in the viewfinder and reshoot.

Problem: Frame counter not working.
Cause: Camera back might not be completely shut. Counter is broken.
Cure: Tightly close camera back before advancing film manually. Professional camera repair.

Problem: No image is seen through viewfinder.
Cause: Lens cap is on the lens. Inside mirror is stuck in the up position.
Cure: Remove lens cap. Professional camera repair.

Problem: Same image defect seen on every picture.
Cause: Crack or debris on filter and/or lens. Possible problem with commercial printer.
Cure: Check filter, lens and negatives for recurring defect.

Problem: No power/readout/film advance.
Cause: Dead batteries. Faulty electrical system.
Cure: Replace batteries. Professional camera repair.

Problem: Rewind knob not working.
Cause: Snapped or bent connection between rewind knob and film cassette fork.
Cure: Professional camera repair.

Problem: Shutter button will not take picture.
Cause: Picture already taken and film not advanced to next frame. Mechanical or electrical malfunction.
Cure: Advance film advance lever. Replace batteries. Professional camera repair.

Problem: Shutter speed ISO setting not on correct number.
Cause: Faulty manual or electrical setting.
Cure: Continue taking the entire roll of film at the incorrect setting and bring the film to a professional developing shop, being certain to tell them of your mistaken ISO.

Problem: Shutter speed dial not turning.
Cause: Stiff or dirty camera. Possible misalignment. Damaged shutter speed dial.
Cure: Clean dial with soft cloth, brush and compressed air. Slightly press down on dial while trying to rotate it. Professional camera repair.

☐ Film/Negatives

Problem: Completely black negatives.
Cause: Large light leak in film cassette or film developing tanks.
Cure: None.

Problem: Black lines running through entire roll of developed film.
Cause: Improper wiping of wet developed negatives, leaving behind chemical debris.
Cure: Resoak negatives in 68 degree water for 10-15 minutes; wipe completely. Use commercial film cleaner.

Problem: All negatives blurred.
Cause: Camera movement while taking pictures.
Cure: None. Next time hold camera steady or shoot with faster shutter speed.

Problem: Completely clear negatives.
Cause: Because of improper loading, the film did not pass through the camera.
Cure: None. Next time fully insert the film leader into the take up spool or, with electronically controlled cameras, place the film leader on the proper take up marking.

Problem: All dark or dense negatives.
Cause: Improper camera exposure. Too long developing time.
Cure: Reshoot, exposing correctly and developing precisely.

Problem: Dark, disk-shaped marks (called air bells) on some negatives.
Cause: Improper agitation during beginning of film development.
Cure: Crop out when making prints. Computer manipulation.

Problem: Finger prints on negatives.
Cause: Too much pressure with fingers on wet negatives.
Cure: None.

Problem: Half moon shapes on negatives.
Cause: Film too tightly squeezed during film loading portion of development process.
Cure: None. Computer manipulation.

Problem: Overlapped frames.
Cause: Improper use of film advance lever. Possible shutter curtain timing problem.
Cure: Completely and fully advance film advance lever. Professional camera repair.

Problem: All pale or thin negatives.
Cause: Improper camera exposure or not left in film developer long enough.
Cure: Reshoot. Develop film precisely.

Problem: Partially black negatives.
Cause: Small light leak in film cassette or film developing tank.
Cure: None.

Problem: Milky colored patches on negatives.
Cause: Undeveloped sections on film due to incorrect film loading and film touching another film surface during development.
Cure: None.

Problem: Negative frames partially cropped.
Cause: Improper shutter speed used during flash photography.
Cure: Reshoot using designated shutter speed for flash on your camera. Professional camera repair.

Problem: Pink or purple transparent cast on negatives.
Cause: Weak or depleted film fixer.
Cure: Re-fix using fresh fixer.

Problem: White or clear lines running through entire roll of film.
Cause: Film emulsion scraped off during film passing through film cassette brushes or abrasive wiping of wet developed negatives.
Cure: None. Possible computer manipulation.

❑ Prints
Problem: Brown or purple stains on prints.
Cause: Improper sequence/timing of baths during development.
Cure: Reprint using correct printing procedures in fresh chemicals.

Problem: Crescent shapes on prints.
Cause: Marks left by improper print tong holding of print during its wet chemical development.
Cure: Reprint and hold different edges of print during developing process.

Problem: Large dark areas on print and border.
Cause: Light leak during paper exposure.
Cure: Reprint making certain all other light sources are turned off.

Problem: Dark areas in print without detail.
Cause: Improperly exposed print. Too long an exposure time or too large a f-stop in the enlarger.
Cure: Make another test strip with a smaller f-stop. Try dodging overexposed area.

Problem: Dark prints.
Cause: Improper camera exposure. Insufficient time in developing negatives. Too long enlarger print exposing time. Too wide or large an enlarger aperture.
Cure: Redo, changing any of the causes.

Problem: Too light prints.
Cause: Improper camera exposure. Negatives developed too long. Enlarger had too small an aperture or was on too short a time.
Cure: Redo, changing any one of the causes.

Problem: Part of photo paper print in focus, other section of paper out of focus.
Cause: Photo paper not flat during exposure. Enlarger not perpendicular to print easel.
Cure: Realign enlarger head. Use flat printing easel.

Problem: Print appears blurry or "shaken."
Cause: Camera movement while taking the photo. Enlarger head or printing easel moved during exposure.
Cure: Re-expose another photo without the extraneous movement.

Problem: Completed and finished prints curl.
Cause: Print paper too thin. Too much hardener in the fixer. Too wet atmosphere.
Cure: Re-print using heavier print paper. Use photo mounting machine to flatten print.

Problem: White areas in print without detail.
Cause: Improperly developed negative. Too short or too high number f-stop on enlarger.
Cure: Re-print. Try burning in area longer.

Problem: White spots on prints.
Cause: Dust on negatives or paper while exposing.
Cure: Clean negatives and area around and including enlarger, and re-print. Manual spotting of print or computer manipulation.

APPENDIX D
Glossary

ASA: American Standards Association – film speed rating system that tells how sensitive a specific type of film is to light. The ASA number is the ISO setting on older 35mm cameras.

aperture: The size of the lens opening through which light passes.

barreling: Distortion where straight lines appear to bow outward towards the edges of an image. It is sometimes referred to as bowing.

burning: Process of darkening parts of a print that are washed out due to overexposure.

chromogenic film: Black & white film in which the final print is developed in color photo chemicals.

convergence: Distortion, often in architectural photos, in which lines that are parallel in reality appear non-parallel in an image.

depth of field: The entire area in front of and behind the focus point.

diffuse: Light that has been scattered by reflection from a non-specular surface or by transmission through a translucent material.

dodging: Photo printing process that results in the lightening of areas in an image that are darkened due to underexposure.

enlarger: Optical instrument used to project an image of a negative onto sensitized photographic paper.

exposure compensation: The process of changing the exposure to offset the averaging effect (averaging to 18% middle gray) of a light meter.

f-stop: The aperture or opening in the lens, represented by a number that indicates the size. The larger the number, the smaller the opening.

fill light: The light source that lightens ("fills in") shadows cast by the key light.

flare: Unwanted light that reflects and scatters inside a lens or camera. When it reaches the film, it causes a loss of contrast in an image.

focal length: The distance from the lens to the focal plane when the lens is focused on infinity. The longer the focal length, the greater the magnification of the image.

focal (film) plane: The plane or surface on which a focused lens forms a sharp image in the camera.

grain focuser: Optical instrument used to enlarge a small part of the projected image, allowing you to see the actual grain structure of the film.

ISO: International Standardization Organization – film speed rating system used in most English speaking countries.

key light: The main source of light in a photograph that defines the texture and volume of the subject.

lens hood: Typically a conical, pyramidal or bellows-shaped device, intended to shield a lens from extraneous light. Also referred to as a lens shade.

panchromatic film: Film that is sensitive to ultraviolet radiation and all colors of light. Panchromatic black & white film records all colors as varying shades of gray.

perspective: The apparent size and depth of objects within an image, different in various focal length lenses.

pincushioning: Distortion, the opposite of convergence, where straight lines appear to bow inward towards the center of an image.

point-and-shoot: Camera type that is usually "auto-everything" with few manual controls. They read the speed of the film, focus, calculate exposure, trigger flash, advance the film and rewind it at the end of the roll.

proof sheet: Test contact print that creates negative-size photographs; used to determine correct lighting, subject arrangement, contrast, and other photographic characteristics.

rangefinder: (1) Device on a camera that measures the distance from camera to subject and shows when the subject is in focus. (2) A camera equipped with a rangefinder focusing device.

safelight: A light used in the darkroom during printing to provide general illumination without giving unwanted exposure.

SLR: single-lens reflex – A camera in which the image formed by the lens is reflected by a mirror onto a ground-glass screen for viewing. The mirror swings out of the way during exposure to let the image reach the film.

specular: Mirror-like reflection.

stock solution: A concentrated chemical solution that is diluted before use.

stop: (1) An aperture setting on a lens. (2) A change in exposure by a factor of two. One stop more exposure doubles the light reaching film or paper.

stop bath: Water or acid solution used between the developer and the fixer to stop the action of the developer.

teleconverter: An extension tube that contains an optical element which increases the focal length of the lens.

test strip: An exposure series on a single piece of photographic paper made to determine the correct exposure time and enlarger f-stop setting.

vignette: To underexpose the edges of an image. Often caused accidentally by a lens that forms an image covering the film or paper only partially.

working solution: A chemical solution diluted to the correct strength for use.

wetting agent: A chemical solution used after washing film. By reducing the surface tension of the water remaining on the film, it is said to speed drying and prevents water spots.

Index

Other Books from
Amherst Media, Inc.

Basic 35mm Photo Guide
Craig Alesse

Great for beginning photographers! Designed to teach 35mm basics step-by-step — completely illustrated. Features the latest cameras. Includes: 35mm automatic, semi-automatic cameras, camera handling, *f*-stops, shutter speeds, and more! $12.95 list, 9x8, 112p, 178 photos, order no. 1051.

Into Your Darkroom Step-by-Step
Dennis P. Curtin

This is the ideal beginning darkroom guide. Easy to follow and fully illustrated each step of the way. Includes information on: the equipment you'll need, set-up, making proof sheets and much more! $17.95 list, 8½x11, 90p, hundreds of photos, order no. 1093.

Wedding Photographer's Handbook
Robert and Sheila Hurth

A complete step-by-step guide to succeeding in the world of wedding photography. Packed with shooting tips, equipment lists, must-get photo lists, business strategies, and much more! $24.95 list, 8½x11, 176p, index, b&w and color photos, diagrams, order no. 1485.

Lighting for People Photography
Stephen Crain

The complete guide to lighting. Includes: set-ups, equipment information, strobe and natural lighting, and much more! Features diagrams, illustrations, and exercises for practicing the techniques discussed in each chapter. $29.95 list, 8½x11, 112p, b&w and color photos, glossary, index, order no. 1296.

Outdoor and Location Portrait Photography
Jeff Smith

Learn how to work with natural light, select locations, and make clients look their best. Step-by-step discussions and helpful illustrations teach you the techniques you need to shoot outdoor portraits like a pro! $29.95 list, 8½x11, 128p, b&w and color photos, index, order no. 1632.

Freelance Photographer's Handbook
Cliff & Nancy Hollenbeck

Whether you want to be a freelance photographer or are looking for tips to improve your current freelance business, this volume is packed with ideas for creating and maintaining a successful freelance business. $29.95 list, 8½x11, 107p, 100 b&w and color photos, index, glossary, order no. 1633.

Lighting Techniques for Photographers
Norm Kerr

This book teaches you to predict the effects of light in the final image. It covers the interplay of light qualities, as well as color compensation and manipulation of light and shadow. $29.95 list, 8½x11, 120p, 150+ color and b&w photos, index, order no. 1564.

Achieving the Ultimate Image
Ernst Wildi

Ernst Wildi teaches the techniques required to take world class, technically flawless photos. Features: exposure, metering, the Zone System, composition, evaluating an image, and more! $29.95 list, 8½x11, 128p, 120 b&w and color photos, index, order no. 1628.

Black & White Portrait Photography
Helen Boursier

Make money with b&w portrait photography. Learn from top b&w shooters! Studio and location techniques, with tips on preparing your subjects, selecting settings and wardrobe, lab techniques, and more! $29.95 list, 8½x11, 128p, 130+ photos, index, order no. 1626

The Beginner's Guide to Pinhole Photography
Jim Shull

Take pictures with a camera you make from stuff you have around the house. Develop and print the results at home! Pinhole photography is fun, inexpensive, educational and challenging. $17.95 list, 8½x11, 80p, 55 photos, charts & diagrams, order no. 1578.

Stock Photography

Ulrike Welsh

This book provides an inside look at the business of stock photography. Explore photographic techniques and business methods that will lead to success shooting stock photos — creating both excellent images and business opportunities. $29.95 list, 8½x11, 120p, 58 photos, index, order no. 1634.

Professional Secrets for Photographing Children

Douglas Allen Box

Covers every aspect of photographing children on location and in the studio. Prepare children and parents for the shoot, select the right clothes capture a child's personality, and shoot story book themes. $29.95 list, 8½x11, 128p, 74 photos, index, order no. 1635.

Handcoloring Photographs Step-by-Step

Sandra Laird & Carey Chambers

Learn to handcolor photographs step-by-step with the new standard in handcoloring reference books. Covers a variety of coloring media and techniques with plenty of colorful photographic examples. $29.95 list, 8½x11, 112p, 100+ color and b&w photos, order no. 1543.

McBroom's Camera Bluebook

Mike McBroom

Comprehensive and fully illustrated, with price information on: 35mm, medium & large format cameras, exposure meters, strobes and accessories. Pricing info based on equipment condition. A must for any camera buyer, dealer, or collector! $29.95 list, 8½x11, 224p, 75+ photos, order no. 1263.

Fine Art Portrait Photography

Oscar Lozoya

The author examines a selection of his best photographs, and provides detailed technical information about how he created each. Lighting diagrams accompany each photograph. $29.95 list, 8½x11, 128p, 58 photos, index, order no. 1630.

Family Portrait Photography

Helen Boursier

Learn from professionals how to operate a successful portrait studio. Includes: marketing family portraits, advertising, working with clients, posing, lighting, and selection of equipment. Includes images from a variety of top portrait shooters. $29.95 list, 8½x11, 120p, 123 photos, index, order no. 1629.

Camcorder Tricks and Special Effects, *revised*

Michael Stavros

Kids and adults can create home videos and mini-masterpieces that audiences will love! Use materials from around the house to simulate an inferno, make subjects transform, create exotic locations, and more. Works with any camcorder. $17.95 list, 8½x11, 80p, order no. 1482.

The Art of Portrait Photography

Michael Grecco

Michael Grecco reveals the secrets behind his dramatic portraits which have appeared in magazines such as *Rolling Stone* and *Entertainment Weekly*. Includes: lighting, posing, creative development, and more! $29.95 list, 8½x11, 128p, order no. 1651.

Essential Skills for Nature Photography

Cub Kahn

Learn all the skills you need to capture landscapes, animals, flowers and the entire natural world on film. Includes: selecting equipment, choosing locations, evaluating compositions, filters, and much more! $29.95 list, 8½x11, 128p, order no. 1652.

Photographer's Guide to Polaroid Transfer

Christopher Grey

Step-by-step instructions make it easy to master Polaroid transfer and emulsion lift-off techniques and add new dimensions to your photographic imaging. Fully illustrated every step of the way to ensure good results the very first time! $29.95 list, 8½x11, 128p, order no. 1653.

Black & White Landscape Photography

John Collett and David Collett

Master the art of b&w landscape photography. Includes: selecting equipment (cameras, lenses, filters, etc.) for landscape photography, shooting in the field, using the Zone System, and printing your images for professional results. $29.95 list, 8½x11, 128p, order no. 1654.

Wedding Photojournalism

Andy Marcus

Learn the art of creating dramatic unposed wedding portraits. Working through the wedding from start to finish you'll learn where to be, what to look for and how to capture it on film. A hot technique for contemporary wedding albums! $29.95 list, 8½x11, 128p, order no. 1656.

Studio Portrait Photography of Children and Babies

Marilyn Sholin

Learn to work with the youngest portrait clients to create images that will be treasured for years to come. Includes tips for working with kids at every developmental stage, from infant to pre-schooler. Features: lighting, posing and much more! $29.95 list, 8½x11, 128p, order no. 1657.

Professional Secrets of Wedding Photography

Douglas Allen Box

Over fifty top-quality portraits are individually analyzed to teach you the art of professional wedding portraiture. Lighting diagrams, posing information and technical specs are included for every image. $29.95 list, 8½x11, 128p, order no. 1658.

Photographer's Guide to Shooting Model & Actor Portfolios

CJ Elfont, Edna Elfont and Alan Lowry

Learn to create outstanding images for actors and models looking for work in fashion, theater, television, or the big screen. Includes the business, photographic and professional information you need to succeed! $29.95 list, 8½x11, 128p, order no. 1659.

Photo Retouching with Adobe Photoshop

Gwen Lute

Designed for photographers, this manual teaches every phase of the process, from scanning to final output. Learn to restore damaged photos, correct imperfections, create realistic composite images and correct for dazzling color. $29.95 list, 8½x11, 128p, order no. 1660.

Storybook Wedding Photography

Barbara Box

Barbara and her husband shoot as a team at weddings. Here, she shows you how to create outstanding candids (which are her specialty), and combine them with formal portraits (her husband's specialty) to create a unique wedding album. $29.95 list, 8½x11, 128p, order no. 1667.

Fine Art Children's Photography

Doris Carol Doyle

Learn to create fine art portraits of children in black & white. Included is information on: posing, lighting for studio portraits, shooting on location, clothing selection, working with kids and parents, and much more! $29.95 list, 8½x11, 128p, order no. 1668.

Infrared Portrait Photography

Richard Beitzel

Discover the unique beauty of infrared portraits, and learn to create them yourself. Included is information on: shooting with infrared, selecting subjects and settings, filtration, lighting, and much more! $29.95 list, 8½x11, 128p, order no. 1669.

More Photo Books Are Available!

Write or fax for a *FREE* catalog:

AMHERST MEDIA, INC.
PO BOX 586
AMHERST, NY 14226 USA

www.AmherstMediaInc.com

Fax: 716-874-4508

Ordering & Sales Information:

INDIVIDUALS: If possible, purchase books from an Amherst Media retailer. Write to us for the dealer nearest you. To order direct, send a check or money order with a note listing the books you want and your shipping address. U.S. & overseas freight charges are $3.50 first book and $1.00 for each additional book. Visa and Master Card accepted. New York state residents add 8% sales tax.

DEALERS, DISTRIBUTORS & COLLEGES: Write, call or fax to place orders. For price information, contact Amherst Media or an Amherst Media sales representative. Net 30 days.

All prices, publication dates, and specifications are subject to change without notice.

Prices are in U.S. dollars. Payment in U.S. funds only.

MTP

D.C. PUBLIC LIBRARY

3 1172 04513 4137

APR 0 9 2010

FEB 2 6 2010
FEB 2 6 2010

JUN 1 0 2002 BAKER & TAYLOR